BILL
REID

COLLECTED

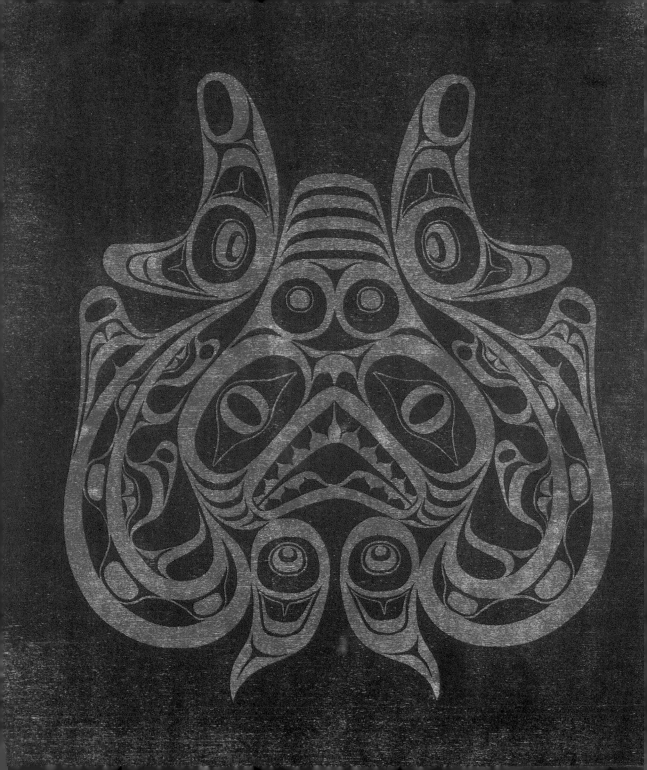

BILL
REID

COLLECTED

MARTINE J. REID

Douglas & McIntyre

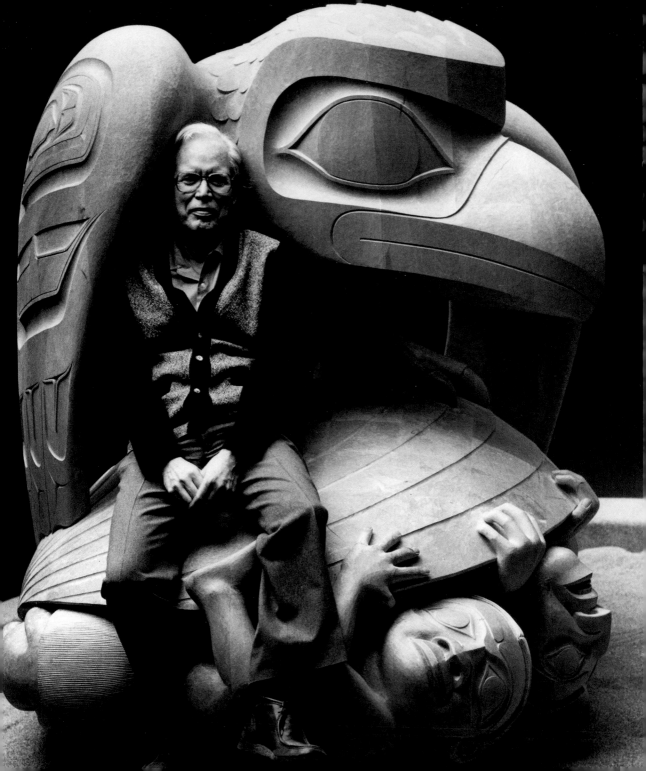

Bill Reid: Deeply Carved

MARTINE J. REID

"Joy is a well-made object." —Bill Reid

A GOLDSMITH TURNED SCULPTOR, master carver and writer, Bill Reid (1920–1998) was one of the most influential Canadian artists of the twentieth century. His passion for the well-made object, combined with the gradual discovery of his rich Haida cultural heritage, informed and inspired his development as a visual artist of great power and daring accomplishment.

Reid lived and worked at the interface between two distinctly different worlds and powerful traditions: Haida and European. And he mastered both of those traditions, despite having grown up outside of his Haida cultural heritage, without surrendering to either. In a career spanning five decades, he melded Haida expressive conventions with elements of Western modernism, crossing many boundaries. It is that fusion of his two worlds—Haida and non-Haida—that characterizes his work, expanding the range of possibilities beyond both traditions.

Bill Reid and *The Raven and the First Men,* 1980, Courtesy UBC Museum of Anthropology, Vancouver. Photo by Bill McLennan

Reid was born in 1920 in Victoria, BC. His elegant Haida mother, Sophie Gladstone Reid of Skidegate, Haida Gwaii, was a descendant of the Wolf matrilineage of the Raven moiety of the village of T'aanuu. His American father, William Ronald Reid, was an immigrant to Canada and ran hotels in Smithers, BC, and, later, in Hyder, Alaska. Reid's last contact with his father was at the age of twelve, when his parents separated. Sophie set up house in Victoria, where she made a living as a designer and dressmaker, crafting fashionable clothes for upper-class families.

Reid's mother did not make any effort to make her children aware of their Native heritage. A survivor of the residential school system, Sophie had been taught that it was sinful to be an "Indian" and took no pride in passing her Haida heritage on to her children.[1] Her personal and cultural identities were further impacted when she was stripped of her Indian legal status for marrying a non-Native man. Ambitious for success in the white world, she raised her children as white Canadians, emulating Western values. Although Reid became aware of his Aboriginal ancestry later in life, he did not know what it meant to be Haida culturally. It would take Reid a lifetime to unearth what his mother had been forced to bury.

To relieve his boredom, twelve-year-old Reid started to whittle ship models and other miniature objects. The only surviving work of his from that time is a tiny Victorian tea set. The teapot (with its detachable lid), sugar bowl and cream jug were all carved from white blackboard chalk,

1 Bill Reid, in *Solitary Raven: The Essential Writings of Bill Reid*, ed. Robert Bringhurst (Vancouver: Douglas & McIntyre, 2009), 115.

and then coated with pink nail polish. Bill's younger sister, Peggy, for whom it had been made, kept it nestled on a bed of cotton balls in a pocket-sized matchbox. Even at an early age, Reid showed skill in small-scale three-dimensional work, as well as his great attention to detail, power of concentration and playful spirit. As an older student, he developed a taste for classical music, jazz and literature—especially English and American poetry—which became lifelong passions.

In 1938, feeling adrift after a year at Victoria College, Reid found work as a freelance radio announcer without pay for a local BC radio station. His knowledge of music and his good command of the English language helped him establish a career in broadcasting. He would make a living in that trade, working for a number of commercial radio stations in eastern Canada for many years.

In 1943, at the age of twenty-three, Reid made his first visit since early childhood to Haida Gwaii. There he reunited with his grandfather, Charles Gladstone (1878–1954), the last in a line of traditional Haida silversmiths. Gladstone had learned those skills from his maternal uncle, the renowned Haida carver and jeweller Charles Edenshaw (1839–1920), from whom Gladstone also inherited his jewelry tools. During his visit, Reid held those tools and admired their fossil ivory handles, which were carved with spirit helper figures. Reid also met the traditionally trained storyteller Henry Young (c. 1871–1968). His admiration for Young's oratory talent and profound knowledge of Haida oral literature would later inspire Reid to write *The Raven Steals the Light* (1984) and to illustrate it with ghostly, intensely shaded three-dimensional pencil drawings.

In 1945, Reid's broadcasting career took him to Toronto, where he eventually worked for the Canadian Broadcasting Corporation (CBC) from 1948 to 1951. His baritone voice and charismatic personality made him a popular figure, but he yearned for a different kind of career. Memories of the Haida bracelets his grandfather had made for his female relatives exerted a powerful draw and compelled him to sign up for a two-year formal goldsmithing course at the Ryerson Institute of Technology. Following that, he embarked on an apprenticeship at the Toronto Platinum Art Company by day while still broadcasting at night. This apprenticeship marked the beginning of Reid's career as a professional artist.

Reid's creative journey has been interpreted as a lifelong quest towards a deep understanding of his Haida heritage and identity, although his work was primarily informed by skills he developed within the European tradition. His artistic career can be divided into three periods: Pre-Haida (1948–1951), Haida (1951–1968) and Beyond Haida (1968–1998). While somewhat arbitrary, these temporal phases correspond to Reid's progression through geographical space, as well as the overlapping of certain of his activities. During the first phase, he worked as a radio announcer by day and an apprentice jeweller by night in Toronto; during the second, he learned totem pole carving and the formal conventions of Haida art in Vancouver; and during the third, he lived and worked in London, Montreal and Vancouver, mastering and melding both Western and Haida styles. So far, nearly a thousand original works have been catalogued, perhaps a little less than half of his entire estimated life's output.

Pre-Haida Phase (1948–1951): Toronto

REID'S CLASSIC WESTERN jewellery training involved learning a wide range of complex metalworking techniques, starting with the most critical one: the carving of space with a single wire and a pair of pliers. This skill led him to master the third dimension, depth, which in turn informed his subsequent creative process. Combined with his insight and ingenuity, as well as his imagination and drive, his understanding of depth freed him from what could have been a rigid adherence to traditional Haida conventions, and allowed him to explore new subject matter, new compositions and new forms.

Through his avid reading of magazines such as *California Arts and Architecture* and *Craft Horizons*, Reid discovered the American modernist jewellery movement, a natural outgrowth of the Arts and Crafts movement, which rejected the machine and championed handcraftsmanship. "For a time Bill envisioned a future as a contemporary jeweler like Margaret De Patta, an American craftswoman, then well-known in jewelry circles," wrote Reid's biographer Doris Shadbolt.[2]

As Reid developed and strengthened his hand-eye coordination, he learned procedures to solve space and design problems. Later, he was known to say that he owed his wide range of artistic accomplishments to the skills that he acquired from the jewellery trade. Reid's wire-sculpting

2 Doris Shadbolt, *Bill Reid* (Vancouver: Douglas & McIntyre, 1998), 25.

skills remained undiminished until his last days, in spite of his Parkinson's disease (diagnosed in 1973, at the age of fifty-three). He could often be seen holding his "knitting kit"—a spool of wire and a pair of pliers—conjuring lively, whimsical creatures from a single wire and space.

While in Toronto, he nurtured his interest in the art of his ancestors by making regular visits to the Royal Ontario Museum. There he studied the essential formal elements embedded in an impressive heraldic pole from his grandmother's village of T'aanuu and in other old Haida works, while also training his eyes to Haida iconography.

Reid neither signed nor dated his early pieces, so we know of few authenticated works from this period. He made a ruby and diamond ring in the Victorian style for his mother; a number of modern-style silver brooches based on the human figure, naturalistic flowers and marine motifs; and geometric, modernist-inspired pieces of jewellery that were set with semi-precious stones. He also attempted to create ornaments in the Haida style, but his early work shows his understanding of this convention was incomplete.[3] While much of Reid's work from this first phase is still to be discovered, what exists shows a commitment to developing his technical skills while exploring in depth the art of his Haida ancestors.

3 For more examples of Reid's early jewellery, see www.theravenscall.ca/en/art.

Haida Phase (1951–1968): Vancouver

THE CBC TRANSFERRED Reid to Vancouver in 1951, and he established a workshop with the intention of designing jewellery inspired by the vast legacy of Haida design. Sharing his workshop with Toni Cavelti, a superb Swiss goldsmith, Reid also created Western-style jewellery.

Reid was the first artist working in the Haida tradition to approach Haida art with a formal grounding in goldsmithing. When he began his quest to understand Haida art, the vitality of the form had been greatly diminished by colonization and culturally repressive laws. Most pieces were made for the developing tourist trade and lacked the refinement, complexity and power of those from the early nineteenth century. Jewellery works were shallowly engraved, signalling a demoralized and disconnected culture in which the memory of the vital essence embedded in the arts was only faintly expressed.

In the nineteenth century, traditional Haida style was ordered by well-defined principles governing rigorous composition and built on a limited range of possibilities. Haida style was very conservative. The emphasis was on the creative use of established forms rather than innovation, although subtle originality within the conventions was displayed. Nineteenth-century Haida artists were both challenged and stimulated by the conventions and often reacted to them with great virtuosity. As Reid

wrote about Haida style, "All is containment and control, and yet there seems to be an effort to escape."[4]

With no one to teach him, Reid started by studying Haida objects depicted in early ethnographic publications and those displayed in museum collections. During seventeen years of intense contemplation of strong original Haida models, Reid respectfully submitted to the conventions of Haida art, "shamelessly copying," to use his own words, the ancient stylized and semi-realistic designs by his ancestors, whose original works he credited. Taught by those silent masters, he began to unlock "the secrets of the old designs," and to understand the artistic logic behind them.

While attending his grandfather's funeral in Skidegate in 1954, Reid held and closely examined a pair of bracelets made by Charles Edenshaw that were "really deeply carved," and he would later say that after that transformative encounter, "the world was not really the same."[5] The bracelets left an indelible impression that compelled him to refine his standards for the making of Haida art.

In the Haida language, which has no general word for "art," the term "deeply carved" means "well-made" and embedded firmly into our minds.[6] "Deeply carved" was for Reid more than craftsmanship, however. "It was

4 Bill Reid, "The Art: An Appreciation," in Wilson Duff et al., *Arts of the Raven: Masterworks by the Northwest Coast Indian* (Vancouver: Vancouver Art Gallery, 1967), 45–46.

5 Doris Shadbolt, *Bill Reid* (Vancouver: Douglas & McIntyre, 1986), 84.

6 Ibid.

the careful and conspicuous three-dimensional embodiment of traditional Haida values: care, formality, stability, humanity."[7] For Reid, who never called himself an artist but rather a "maker of things," deep-carving and well-making lay at the heart of his aesthetic belief.

Inspired by the works of his great-great-uncle "Charlie" Edenshaw and those of John Cross, Tom Price and his grandfather, Reid at first thought that his only contribution could be putting himself in the place of his ancestors and recreating a selection of old designs with his new technology.

Newly rendered in gold and silver, old two-dimensional tattoo designs found in ethnographic documents resonated with a depth of feeling and convincing power. Designs that in the past were pricked or etched into the skin received similar treatment in gold, silver and argillite, while still conveying identity and spiritual connections through crest figures and/or guardian spirits.

Fastidious in his self-teaching, Reid became eloquent in the traditional Haida visual language—understanding, internalizing and mastering its essential forms and underlying dynamics—the components of which his colleague Bill Holm later codified as the "formline," the "ovoid" (a slightly squared-off oval with a concave bottom) and the "U" form.[8] The formline

7 Marjorie Halpin, book review of *Bill Reid* by Doris Shadbolt for Douglas & McIntyre, 1986, p. 14. The review appeared on pp. 13–15 of a brochure promoting new books.

8 Bill Holm, *Northwest Coast Indian Art: An Analysis of Form* (Seattle: University of Washington Press, 1965).

is a curvilinear dynamic line of constantly varying width similar to calligraphy and expressive of contained energy and tension. A primary formline not only delineates the form, but is the form itself. The other elements—secondary formlines and tertiary elements—provide highlights and detail but remain subservient to the dominant formline. Like calligraphy, the formline both delineates the subject while creating it: it is both the subject and its representation. The formline ovoid is the building block on which this language is built and is mostly used for eyes and joints in abstract or semi-realistic human, animal or mythic creatures.

Reid would apply his new visual language to new subject matter while progressively shifting to freer personal expression. One such novelty was a series of silver engravings executed in the mid-1950s depicting episodes of Haida myths, intended for the medium of printing. These were precursors of the two-dimensional artistic expressions of his later phase: serigraphs, woodcuts, etchings, lithographs and works printed on paper and textiles.

Reid also introduced innovative techniques, such as silver overlaid on silver, and repoussé, in which a surface is ornamented with designs in relief hammered out from the back by hand. Both techniques resulted in a greater three-dimensionality that was lacking or only suggested in earlier Haida metalwork.

Exploring the concept of movement through space, Reid created a pair of killer whale earrings with dangling flukes, as well as several articulated necklaces. This concept was refined during his third period, with transformation necklaces that were inspired by Northwest Coast transformation masks, wherein two or more creatures magically occupy the same space at

the same time. For example, the gold *Dogfish Woman Transformation Necklace* (1991), with its movable parts, could be worn in five different ways.

In 1956, at the invitation of the Provincial Museum of British Columbia in Victoria, Reid worked for two weeks under the direction of Kwakwa-ka'wakw master carver Mungo Martin to recreate a Haida pole—the only training in woodcarving he ever received. Still at the CBC, that same year he wrote and recorded the voice track for *People of the Potlatch*, an important exhibition of Northwest Coast art at the Vancouver Art Gallery. In 1958, several of his creations were exhibited in the Canadian Pavilion at the World's Fair in Brussels. In 1959, he narrated *Totem*, a TV documentary recounting a 1957 expedition to salvage Haida totem poles. Having participated in the expedition, his narration conveyed most ardently his admiration for Northwest Coast art. [9]

Reid's work in the Haida medium brought him a commission from the UBC Museum of Anthropology to recreate a section of a Haida village on the campus, a project that allowed him to leave the CBC and fully commit himself to his art practice. With one assistant, he built two houses and seven poles between 1958 and 1962.

Of the wide range of materials with which he worked—white and yellow gold, platinum, silver, copper, wood, fossil ivory, argillite (a soft black slate found only in Haida Gwaii), leather and hide, paper, cloth, plaster, clay, bronze—Reid loved 22-karat gold the most. Gold's luster, warmth,

9 The documentary *Totem* (known as *Rescuing the Timeless Totems of SGang Gwaay*) is available in the CBC Digital Archives (www.cbc.ca/archives), along with many other videos of Reid's work.

malleability and sensual qualities, as well as its long history of transformation by human hands, imbued it with a mythic aura that most aroused his inspiration.

Fusing his mastery of the repoussé technique with his woodcarving skills, Reid created powerful three-dimensional pieces of jewellery that were deeply carved. He inlaid some with fossil ivory or *Haliotis* (abalone) shell. These added rich textures and shimmering patterns to the pieces as well as a sense of movement, vigour and vitality.

Reid searched for ways to diversify joints and create original clasps "that should snap," as he frequently said while demonstrating a well-made clasp. He also made exquisite, yet highly sculptural, precious hollowware, such as his first 22-karat gold *Eagle and Bear Box*, which was exhibited in the Canadian Pavilion at Expo '67 in Montreal. While the Bear design on the box was executed with repoussé and chasing techniques, the semi-realistic three-dimensional Eagle on the lid was constructed freehand from more than thirty rolled gold sheets that he pre-formed and soldered together. The freestanding bird seems to have just landed on the lid to become its handle. That same year, he also worked as a guest curator of the landmark exhibition *Arts of the Raven: Masterworks by the Northwest Coast Indian* at the Vancouver Art Gallery, which included a selection of his works.

In the late sixties, Reid produced a large-scale laminated cedar screen for the Provincial Museum of BC that was inspired by small, laterally composed nineteenth-century slate carvings. It incorporated five intricately intertwined but distinct mythic narratives and was a precursor to his later monumental works.

His grasp and elegant execution of formal Haida-inspired designs, coupled with his growing design sensitivity, set him free to express his own individuality in his work. After nearly twenty years of deep immersion in Haida style, Reid finally grew confident enough to abandon the words "Haida art," which had been part of his signature.

Beyond Haida Phase (1968–1998)
London (1968), Montreal (1969–1973), Vancouver (1973–1998)

IN ENGLAND, ON a fellowship from the Canada Council to study museum pieces, Reid attended the London School of Design, where he learned to cast precious metals with the lost-wax process. He then moved to Montreal, where he set up a jewellery workshop. In the next four years, he created highly diverse works, such as the gold and diamond necklace with detachable brooch known as the *Milky Way* (1969) and *The Raven Discovering Mankind in a Clamshell* (1970), a 7-centimetre-high sculpture carved out of boxwood and inspired by the Haida creation myth, which would be the original maquette for his larger version, *The Raven and the First Men* (1980).

Reid's experience working with large-scale woodcarvings and small-scale goldsmithing allowed him to create a wide range of artworks, from the "monumentally small" to the "exquisitely huge," as he referred to them. The former category includes precious and refined gold containers surmounted by three-dimensional mythical creatures from his favourite bestiary: the 10-centimetre-high *Killer Whale Box with Beaver and Human*

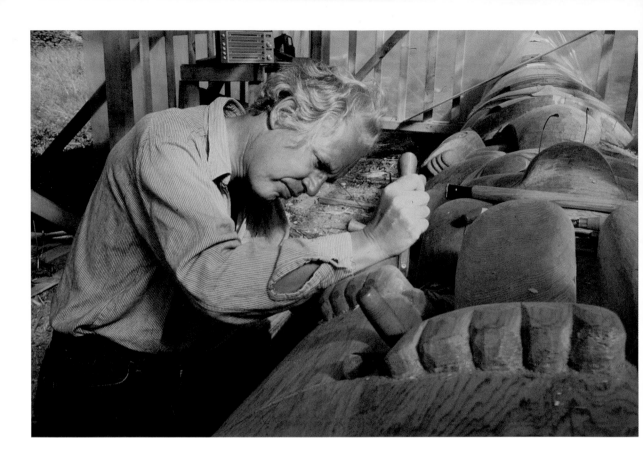

Bill Reid Carving Skidegate Totem Pole, 1976. Photo by Martine Reid

made for the exhibition *The Legacy* at the Provincial Museum (1971), and the 7.3-centimetre-high *Haida Myth of Bear Mother* (1972), commissioned by the National Museum of Man in Ottawa. The "exquisitely huge" includes the massive, 2-metre-high laminated yellow cedar sculpture *The Raven and the First Men* (1980), made for the UBC Museum of Anthropology, and *Phyllidula—the Shape of Frogs to Come* (1984–1985). Named after an epigram by American modernist poet Ezra Pound, *Phyllidula* is a 1.2-metre red cedar sculpture of a sensuous frog, crouched and ready to spring.

With these and other sculptures in the round, as well as with the boxwood *Dogfish Woman Transformation Pendant* (1982), Reid broke the rules of containment imbedded in the formal conventions of Haida art and achieved individual authenticity (as Edenshaw had done before him, albeit on a smaller scale). While the traditional art was a support for Reid to lean on in the early days, it later became a bridge to cross into his own artistic future.

As Reid continued to explore new media for his sculptures, he introduced bronze to Northwest Coast art with a number of large-scale works, the full-size clay and plaster models of which were created in his Granville Island studio with a team of dedicated and talented assistants and technicians. Those works included *Mythic Messengers* (1984), an 8.5-metre-long frieze connecting eleven creatures in symbolic communication, and *Skaana—Killer Whale, Chief of the Undersea World* (1984), the 5.5-metre-high leaping orca commissioned for the Vancouver Aquarium.

Reid's close connection with Haida art led him inexorably to a closer involvement and a deeper concern for the Haida people and their causes.

He spent the summers of 1976 and 1977 in Skidegate, carving a highly symbolic 18-metre-high house frontal pole, which he gave to his mother's community. Completed in 1978, that heraldic pole was the first to be erected in Skidegate in a century.

His insight into, and passion for, the quintessential Haida canoe compelled him to experiment with canoe making. He saw the canoe (as well as the formline ovoid) as perhaps the source of distinctive Haida and other northern Northwest Coast art forms. It was a thought that he expressed unequivocally: "Western art starts with the figure, Northwest Coast art starts with the canoe."[10] Reid worked out design and construction problems by making a series of smaller canoes before he and his team hollowed out and steamed a single eight-hundred-year-old red cedar log to make the 17-metre-long *Lootaas*, the first ocean-going canoe of that size to be built in nearly a century in Skidegate. After being exhibited during Vancouver's Expo '86, the *Lootaas* was triumphantly paddled seven hundred kilometres back home to Skidegate by a mostly Haida crew. That epic journey has inspired many such journeys on the coast, culminating with the Tribal Journeys of the twenty-first century.

Reid's last two bronze sculptures were monumental vessels filled to overflowing with creatures of Haida mythology mixed with those of his own imagining. The iconic sculpture *The Spirit of Haida Gwaii*, nicknamed *The Black Canoe* (at the Canadian Embassy in Washington, DC, 1991), along with its twin, *The Jade Canoe* (at the Vancouver International Airport, 1996),

10 Doris Shadbolt, *Bill Reid* (Vancouver: Douglas & McIntyre, 1998), 112.

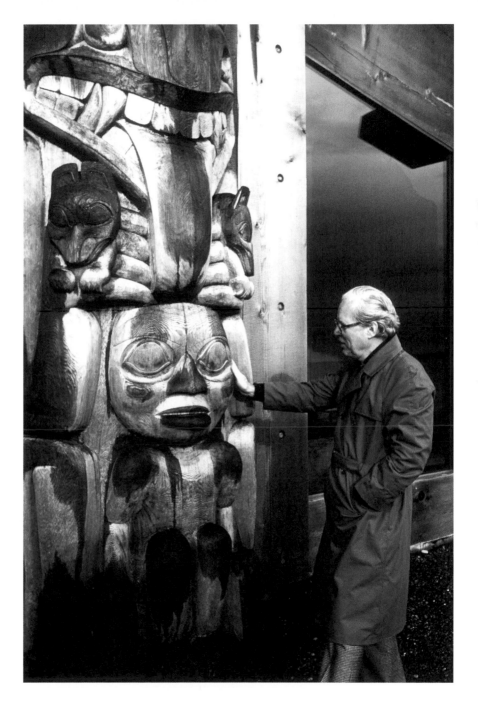

Bill Reid and Skidegate Totem Pole, 1978. Photo by Dr. George MacDonald

were also born of Reid's fascination with Haida canoes and their power to connect.

Reid was gratified by several retrospectives and international solo exhibitions, which celebrated his work during his third period. In 1974, *Bill Reid: A Retrospective Exhibition*, with over two hundred artworks, was held at the Vancouver Art Gallery. Further exhibitions were hosted in 1986, at the UBC Museum of Anthropology, Vancouver; 1989, at the Musée de l'Homme, Paris; 1993, at the Néprajzi Múzeum, Budapest; and 1997, a year before his death, at the Canadian Embassy Gallery, Tokyo.

When Reid was invited to have his work exhibited at the Musée de l'Homme in *Les Amériques de Claude Lévi-Strauss* (1989)—the first time ever that the Parisian institution displayed the art of a living artist—he insisted that *Lootaas* be more than just a static part of the exhibition. Paramount to him was that *Lootaas* not be seen as only a museum artifact but as a vibrant, aesthetic and integral component of Haida culture. His wish became reality. A crew of fifteen Haida paddlers powered the elegant vessel up the Seine River from Rouen to Paris in a week as a lively and powerful interactive display of contemporary Haida art.

Reid's inspiration had its source in the exceptionally rich and beautiful environment of Haida Gwaii and its bestiary—animal, human and mythical. Intent on leaving marks beyond his art that would impact Haida Gwaii as a whole, its inhabitants and their land, Reid actively participated in several campaigns for the preservation of the natural beauty and resources of Haida Gwaii. In 1985 and 1986, to support the creation of the Gwaii Haanas National Park Reserve in South Moresby, Haida Gwaii, he created

two lithographs—*Two Killer Whales* and *Three Whales for South Moresby*—and gave both editions to the Haida Nation, with the proceeds from their sale dedicated to supporting that cause.

His final request, to have his ashes paddled aboard *Lootaas* to his maternal ancestral home, was perhaps his last creative act. In an unprecedented state funeral ceremony, the two sides of Haida society—the Ravens and the Eagles—were reunited for a ceremony in T'aanuu for the first time in nearly a century.

Legacy

REID WAS INSTRUMENTAL in introducing to the world the great art traditions of the Indigenous peoples of the Northwest Coast of North America. His legacies include infusing those traditions with modern techniques and new conceptual forms of expression, styles, genres and media; teaching and influencing emerging artists (some of whom have themselves become master artists); and building lasting bridges between First Nations and the larger world.

By diving deeply into Haida iconography and mythology to reach the essence and roots of a unique art style, Reid was able to discover his own "Haidaness." In the process of becoming "deeply carved" himself, he became a catalyst for the restoration of much of the dynamic power, magic and possibility to the art of the Haida Nation.

Reid, Bill, and Robert Bringhurst. *The Raven Steals the Light*, 2nd ed., with a preface by Claude Lévi-Strauss (Vancouver: Douglas & McIntyre; Seattle: University of Washington Press, 1996).

Reid, Bill, and Adélaide de Ménil. *Out of the Silence* (New York: Outerbridge & Dienstfrey, 1971).

Reid, Bill, and Bill Holm. *Form and Freedom: A Dialogue on Northwest Coast Indian Art* (Houston: Institute for the Arts, Rice University, 1975).

Reid, Martine J., ed. *Bill Reid and the Haida Canoe* (Madeira Park: Harbour Publishing, 2011).

Shadbolt, Doris. *Bill Reid*, 2nd ed. (Vancouver: Douglas & McIntyre, 1998).

The Raven's Call, website, a joint project of the Bill Reid Foundation and the Virtual Museum of Canada, established 2008. www.theravenscall.ca.

Wisnicki, Nina. *I Called Her Lootaas*. Documentary film, with script written and narrated by Bill Reid (Vancouver: William Reid Ltd. and CBC, 1989).

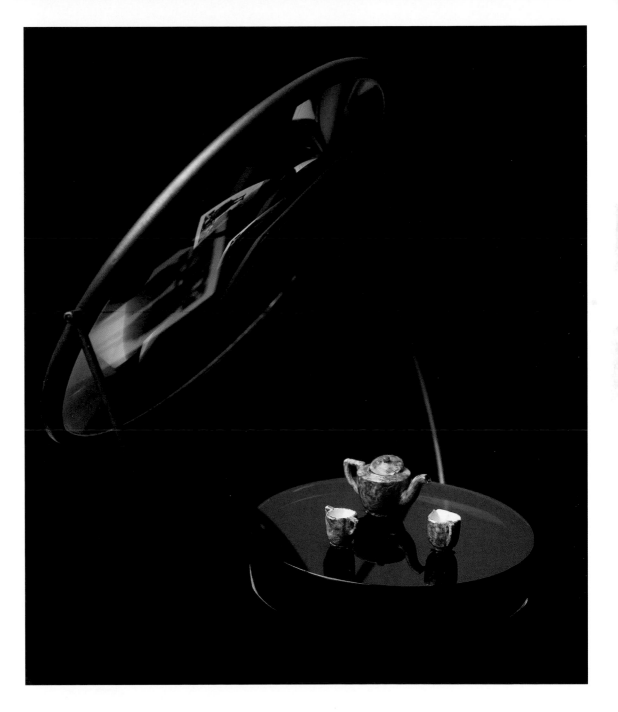

Miniature Tea Set c. 1932 27

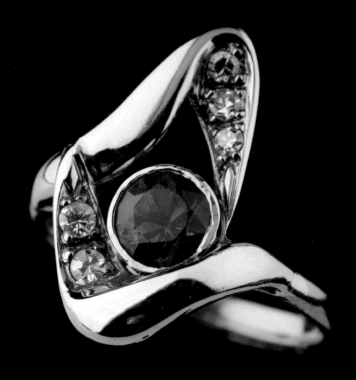

Ruby Ring c. 1948

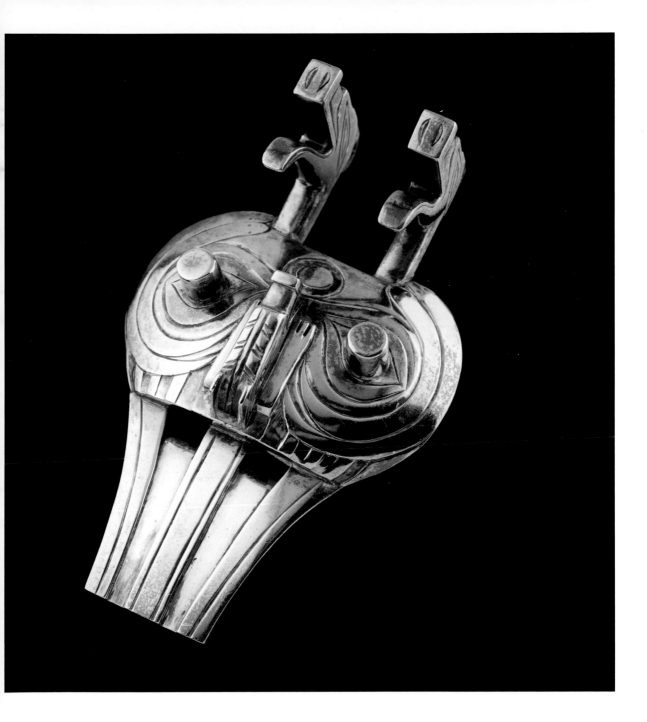

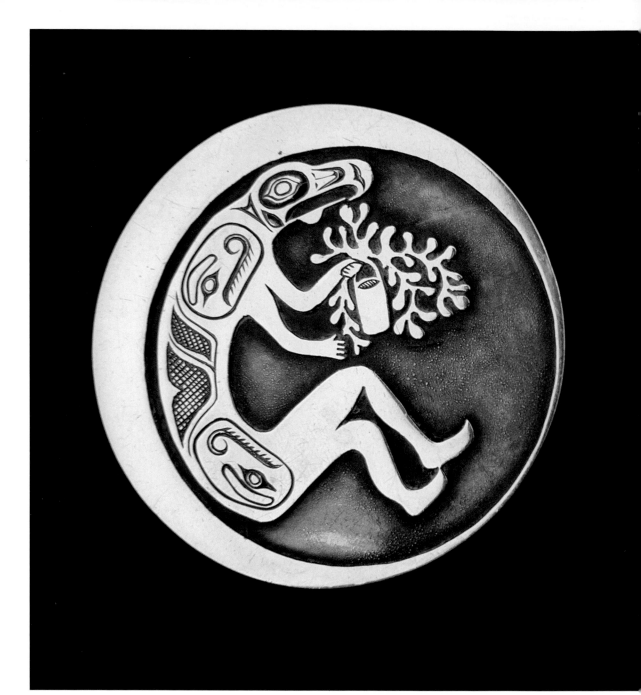

Woman in the Moon Pendant/Brooch 1954

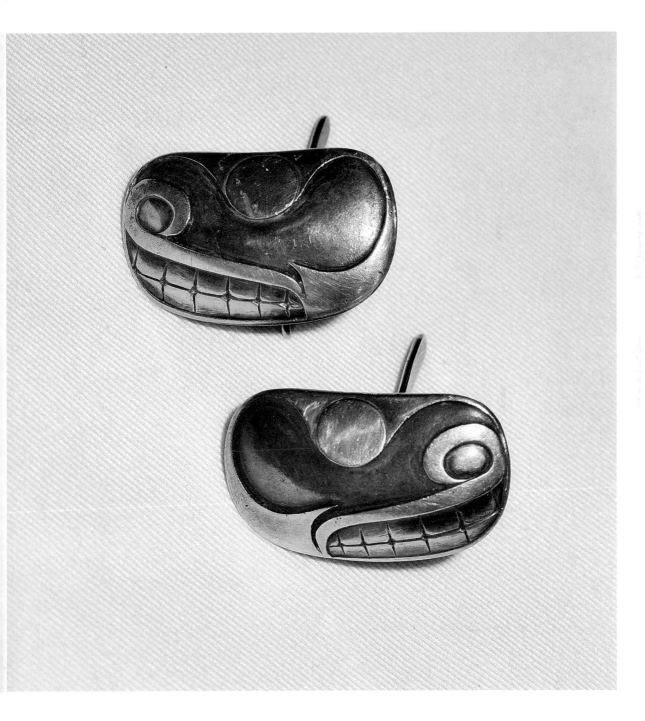

Cufflinks C. 1955 31

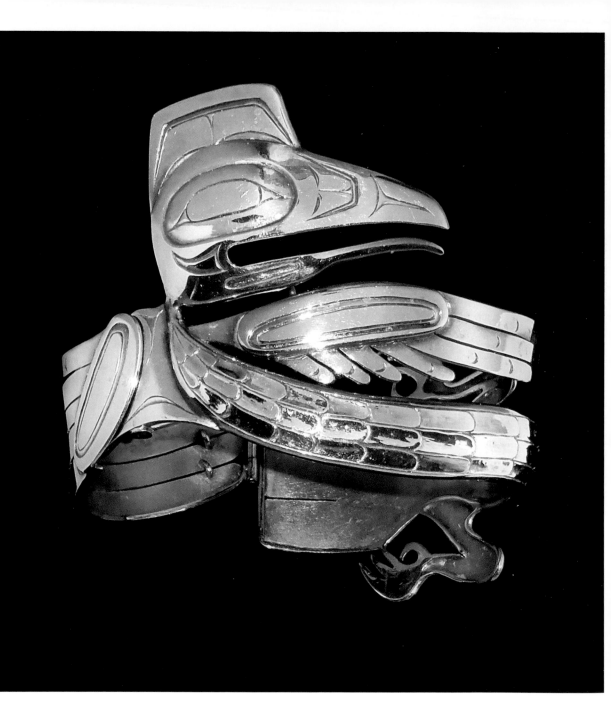

32 **Hinged Raven Bracelet** C. 1955

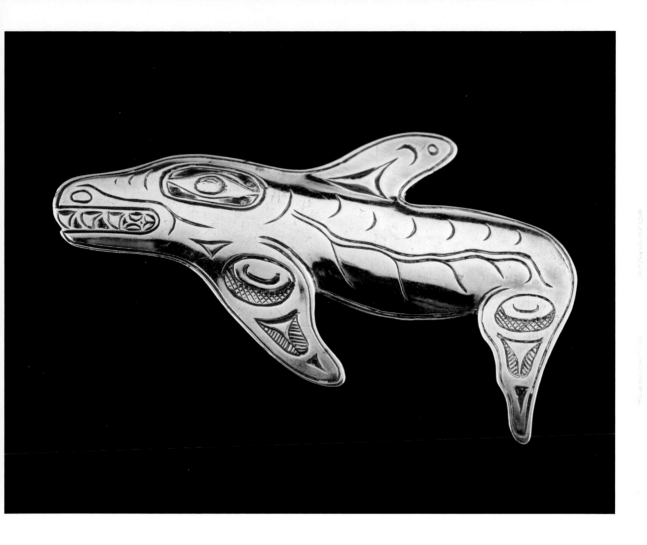

Killer Whale Brooch c. 1955 33

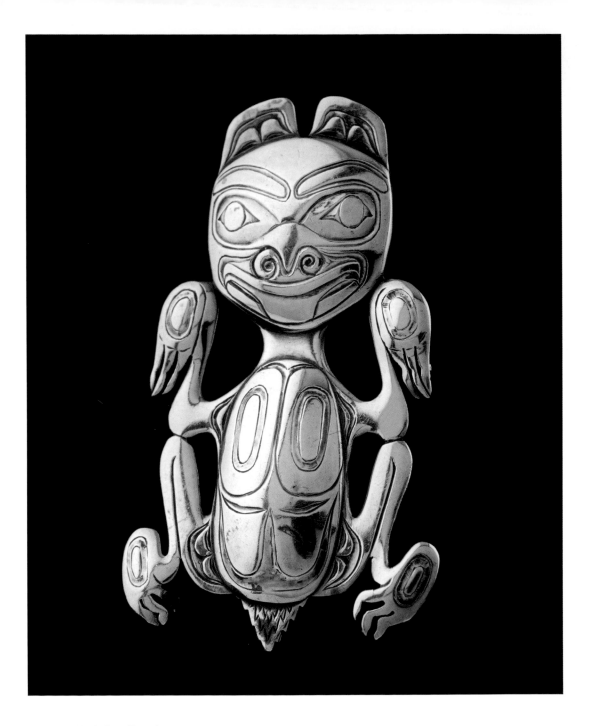

Haida Bear Brooch c. 1955

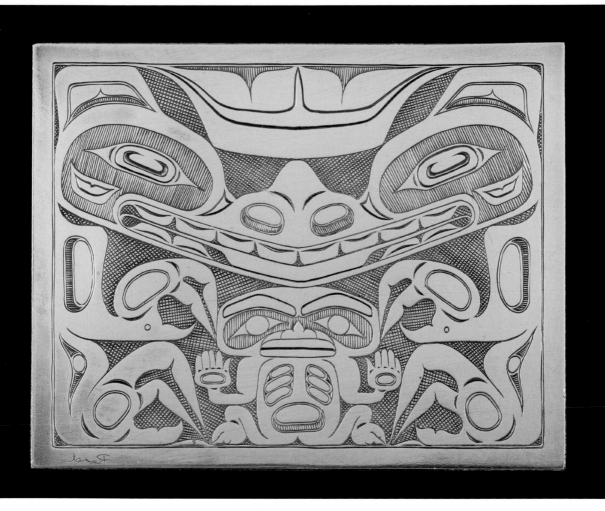

Bear Mother Story Silver Engraving Block C. 1955 35

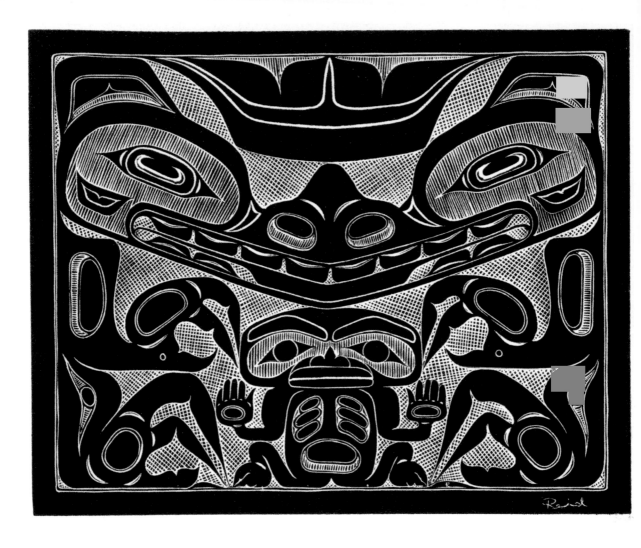

Bear Mother Story Engraving 1955/1989

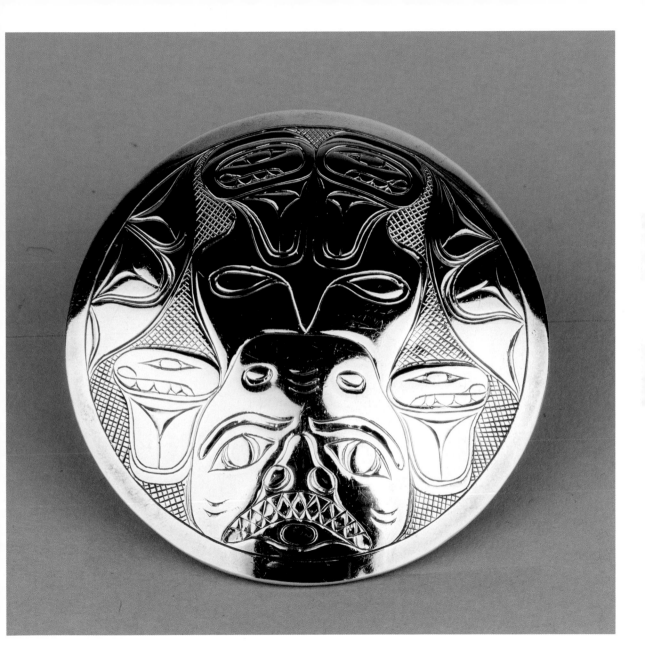

Dogfish Woman Pendant c. 1956 37

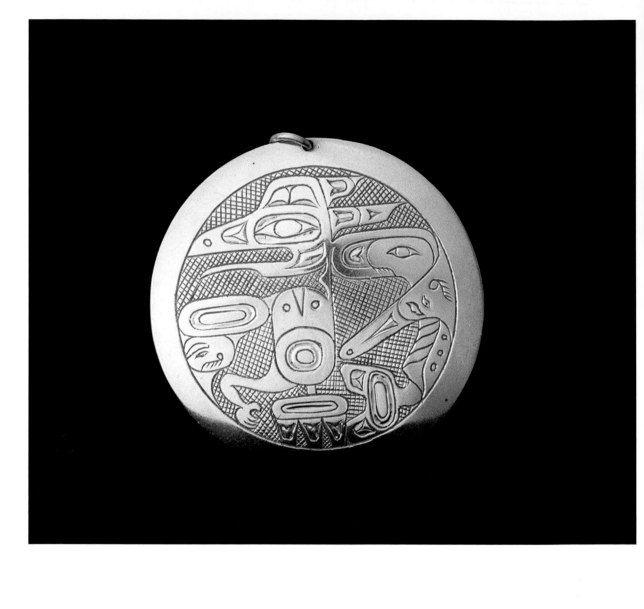

Pendant with Raven and Whale Tattoo Designs. Based on a Drawing by Charles Edenshaw 1956

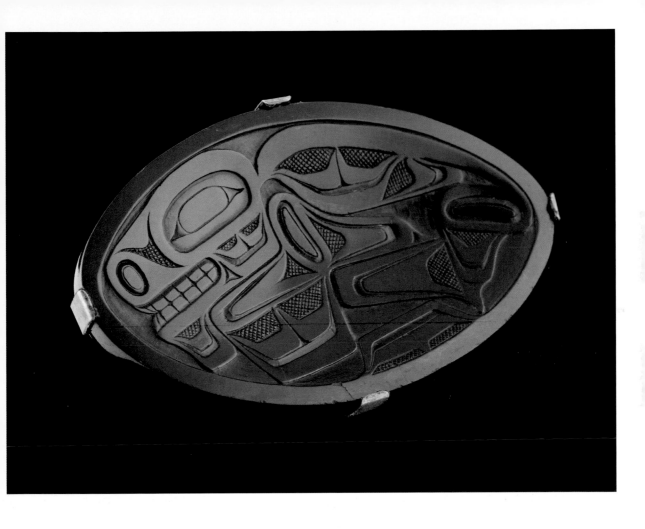

Tschumos Dish 1956 39

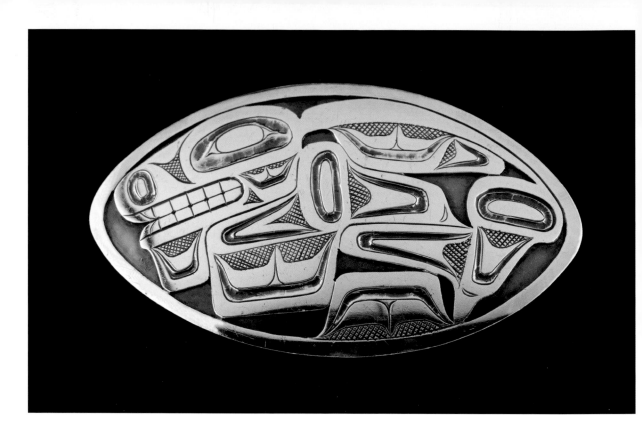

Tschumos Brooch c. 1956

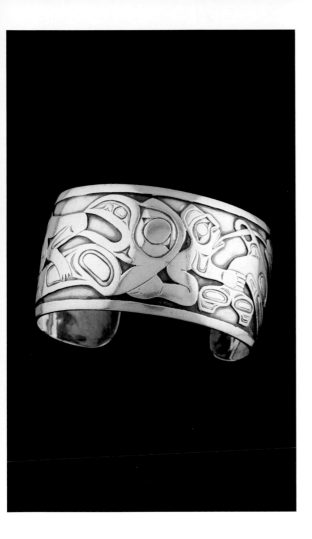
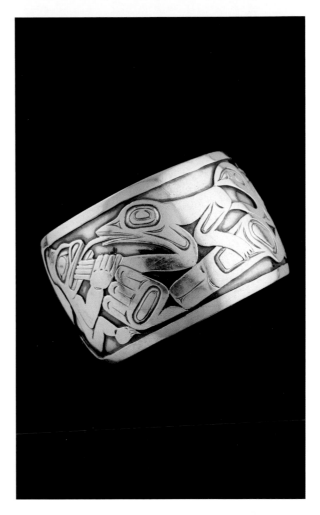

Bracelet with Bear, Frog, Eagle, Man, Killer Whale, Raven c. 1956　41

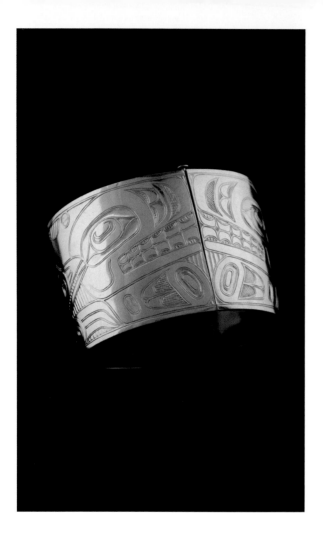

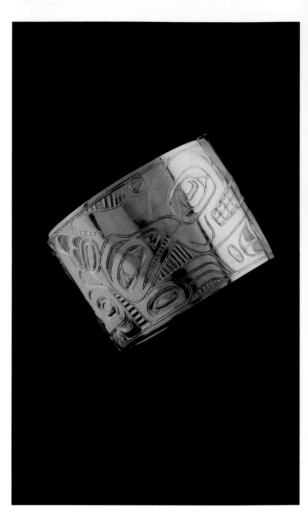

Hinged Gold Bracelet 1957

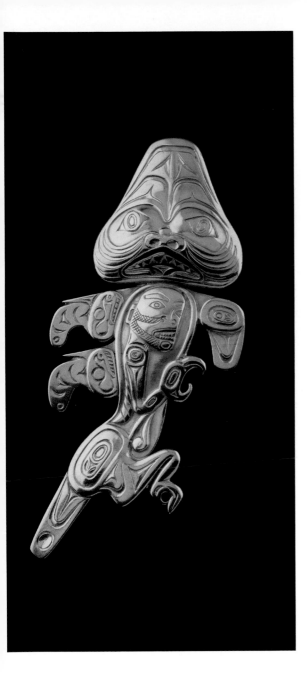

Dogfish Brooch, After a Tattoo Design by Charles Edenshaw c. 1957 43

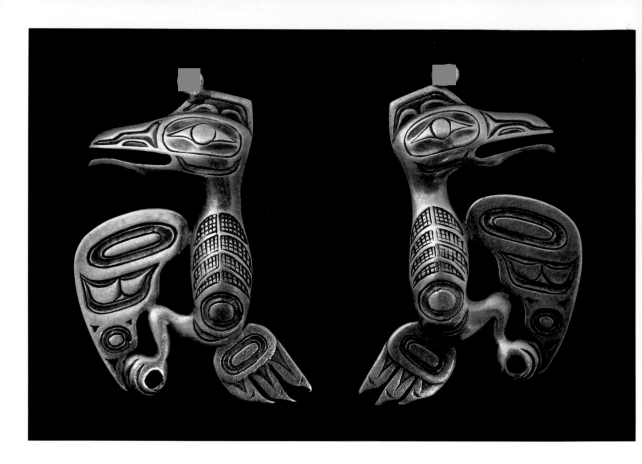

44 **Raven Earrings** C. 1957

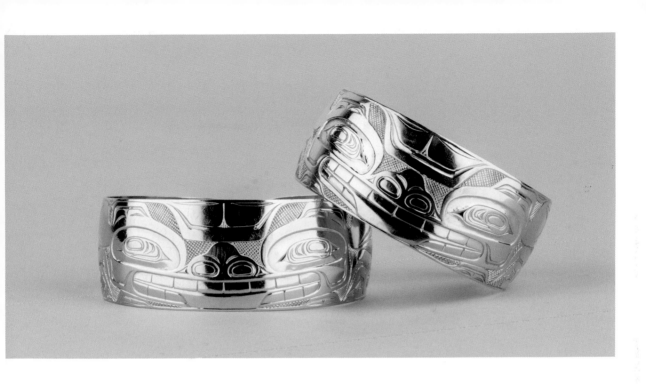

Hawk Earrings c. 1958

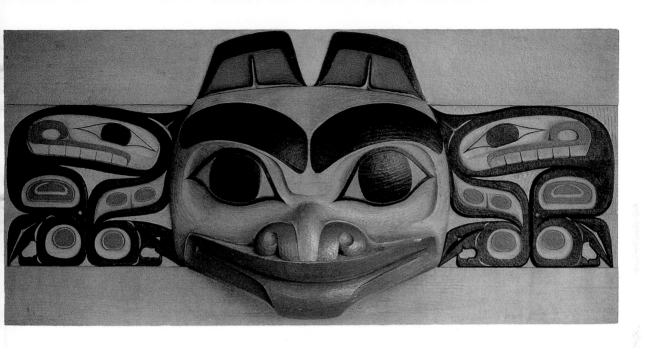

Grizzly Bear Mantelpiece c. 1958 47

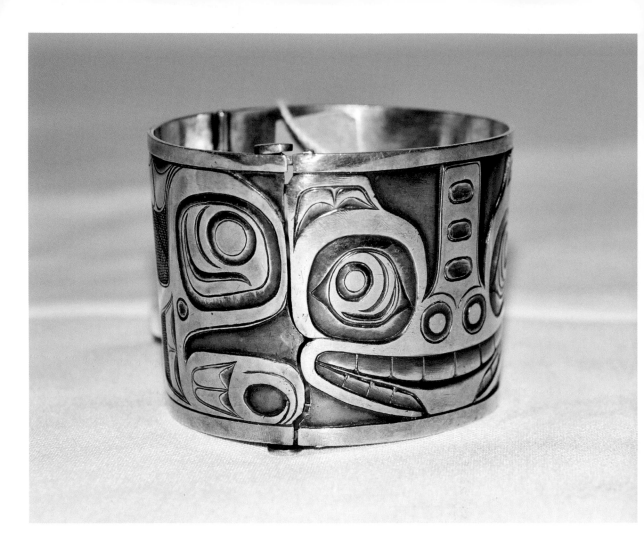

48 *Tschumos* Bracelet c. 1958

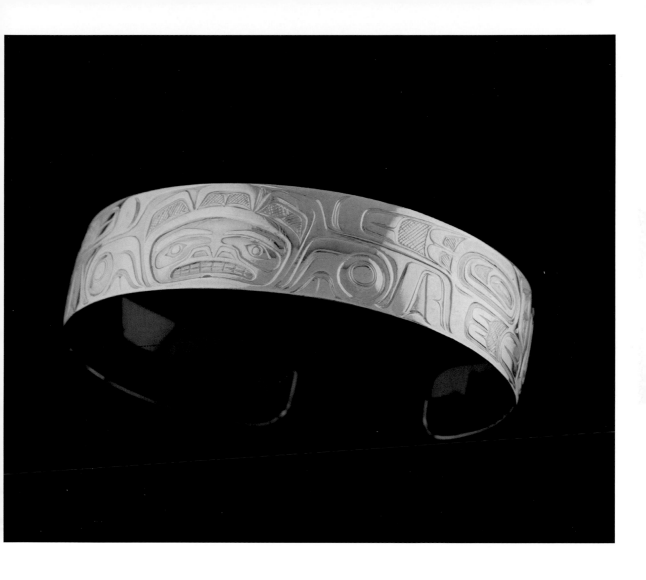

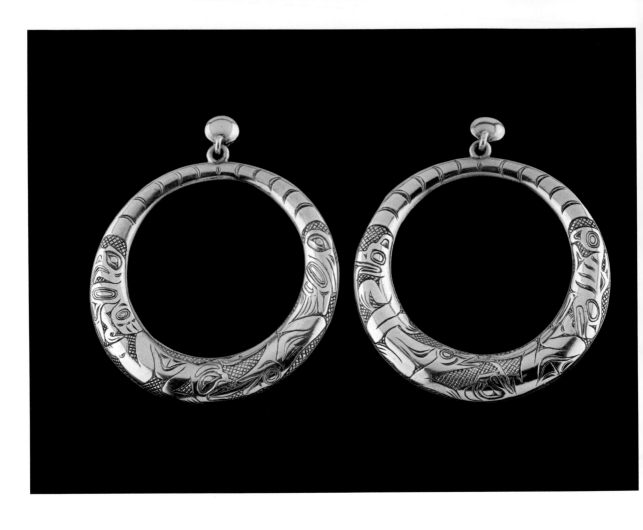

Hoop Earrings with Mythic Narratives c. 1960

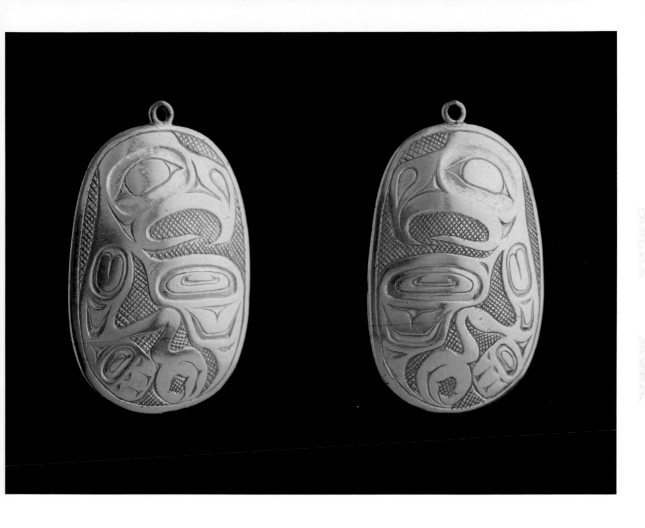

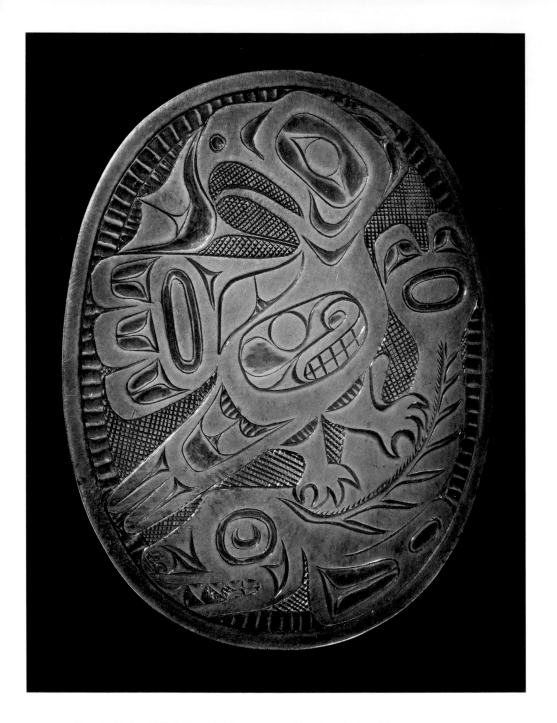

Thunderbird and Whale Brooch After a Charles Edenshaw Argillite Plate 1960

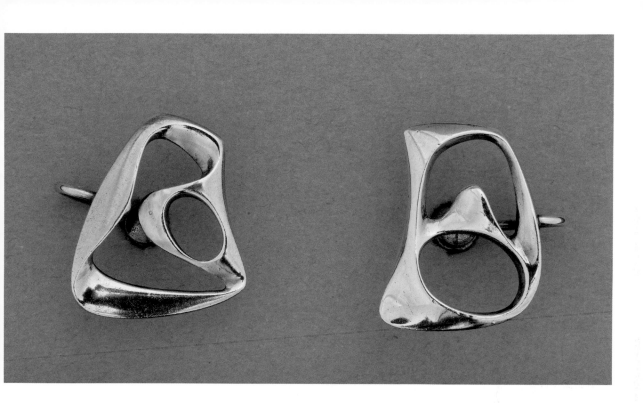

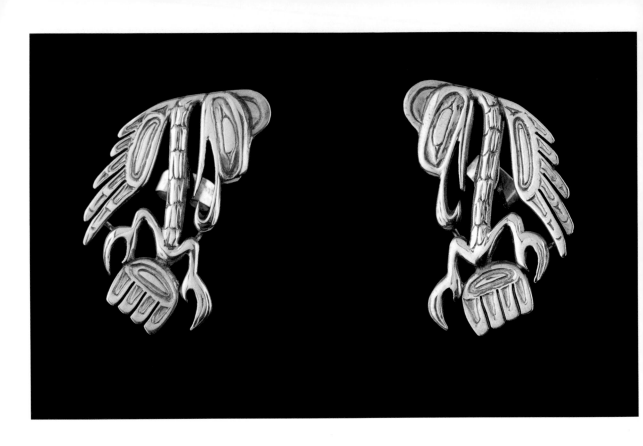

Thunderbird Earrings, After a Tattoo Design by John Wi'ha 1961

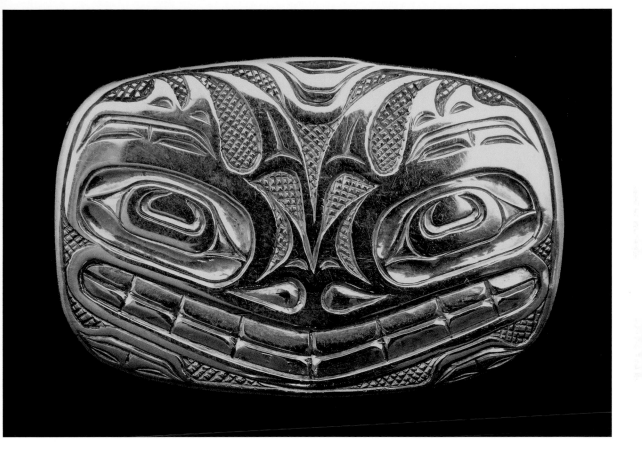

Sculpin Brooch c. 1961

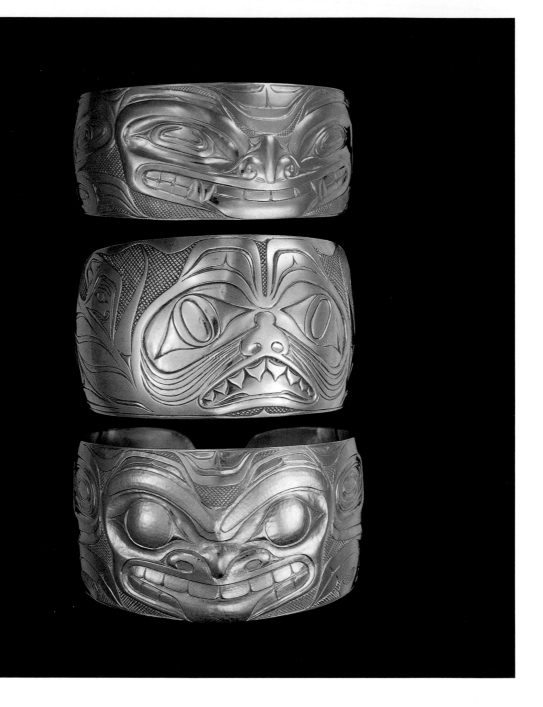

Group of 3 Bracelets: Wolf, Dogfish and Grizzly Bear 1958–1962

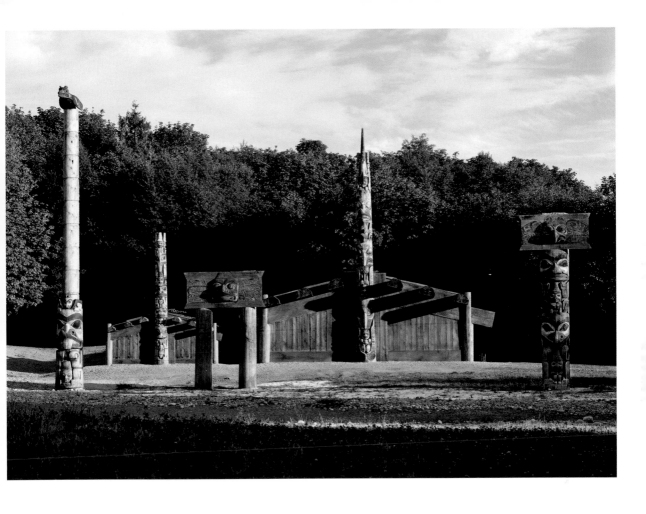

Haida Village 1958–1962 57

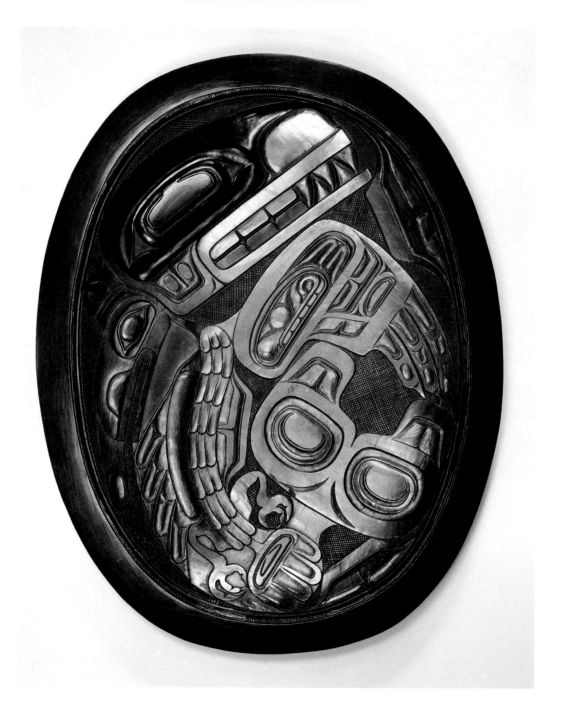

Argillite Platter with Killer Whale and Raven 1962

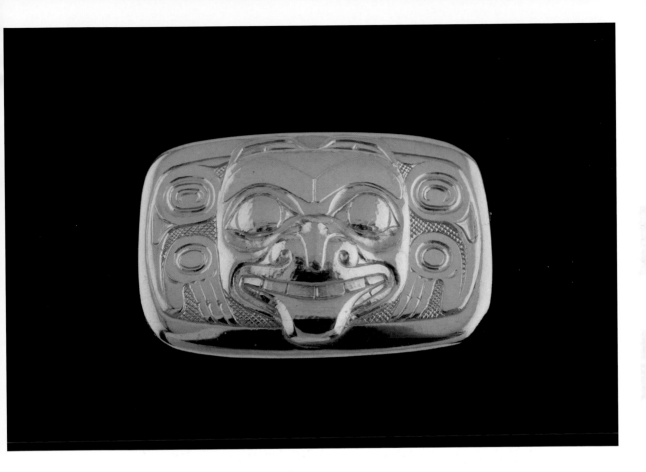

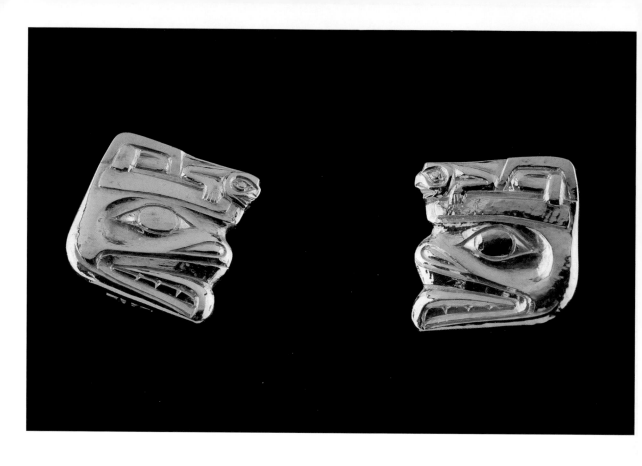

Bear and Human Earrings 1962

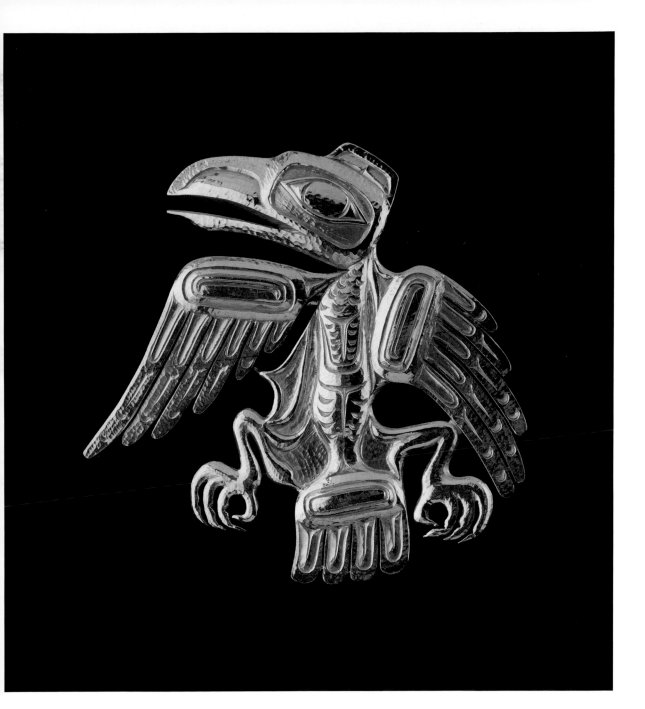

Raven Brooch 1962 61

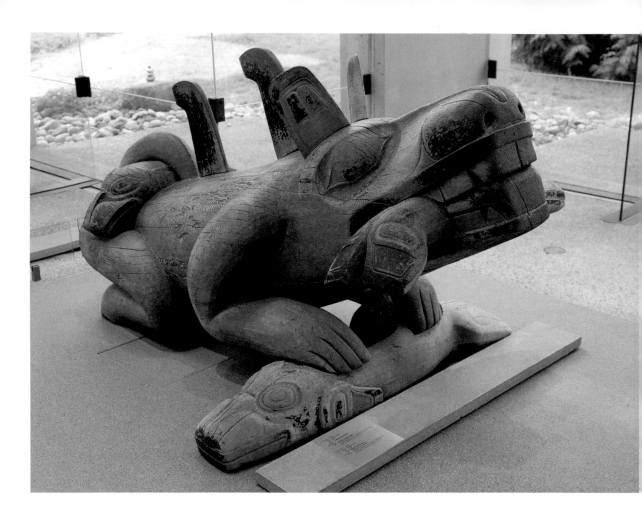

Wasgo (Sea Wolf) Sculpture 1962

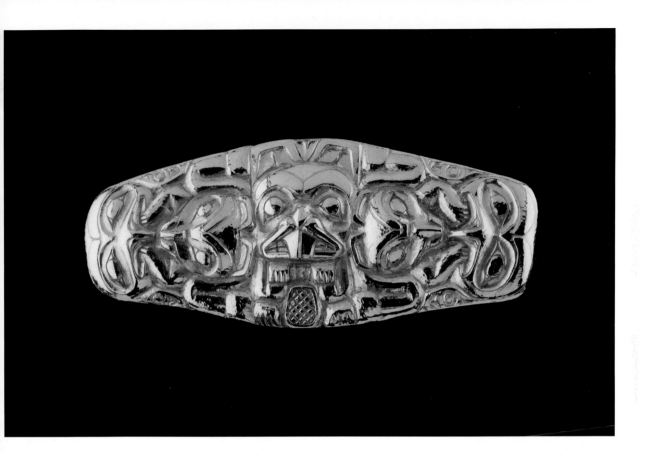

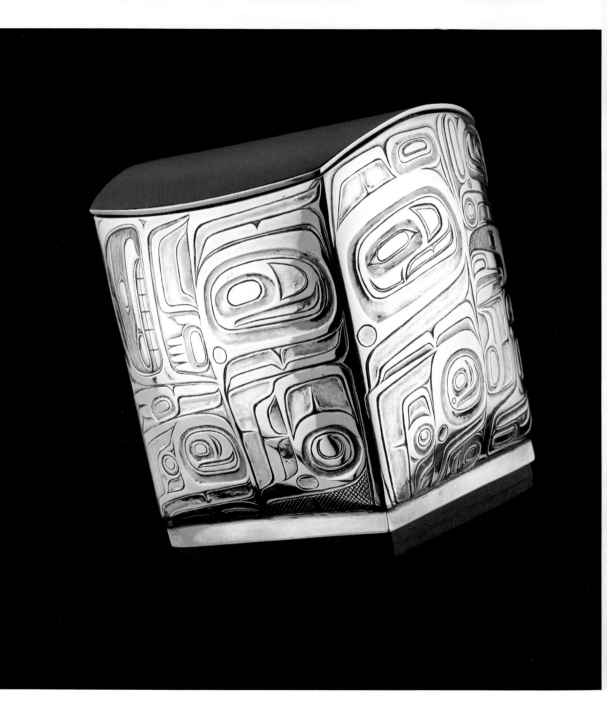

Box with Lid: "The Final Exam" 1964

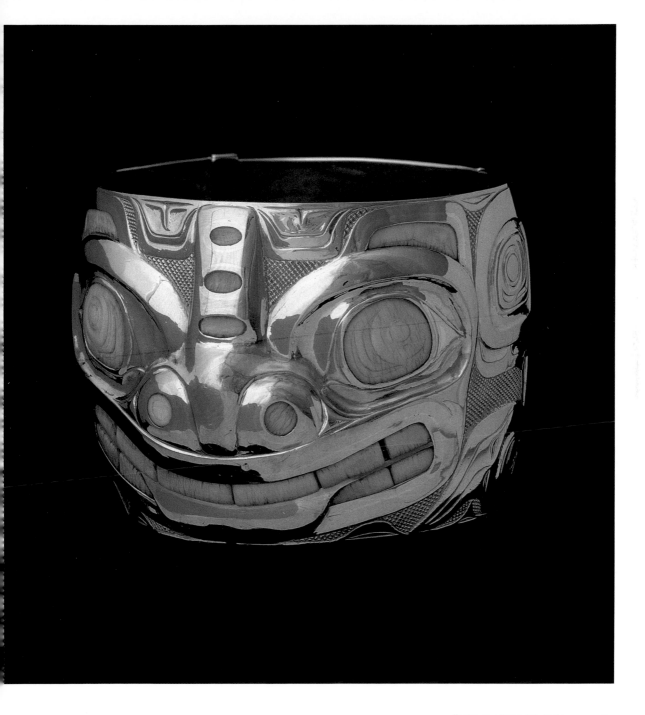

Tschumos Bracelet 1964 65

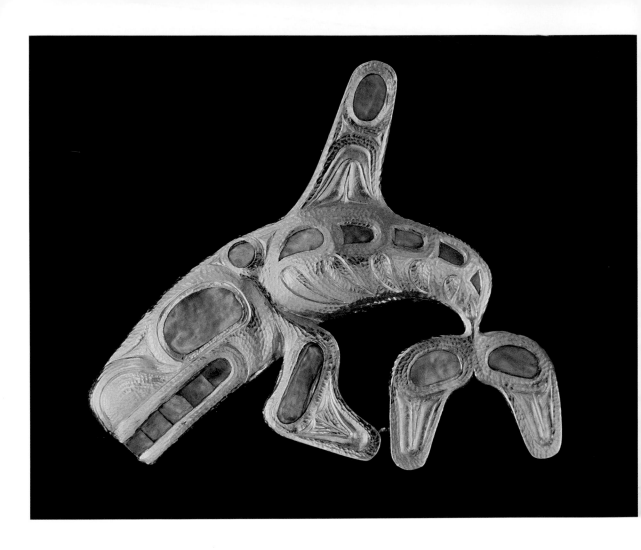

Killer Whale Brooch 1964

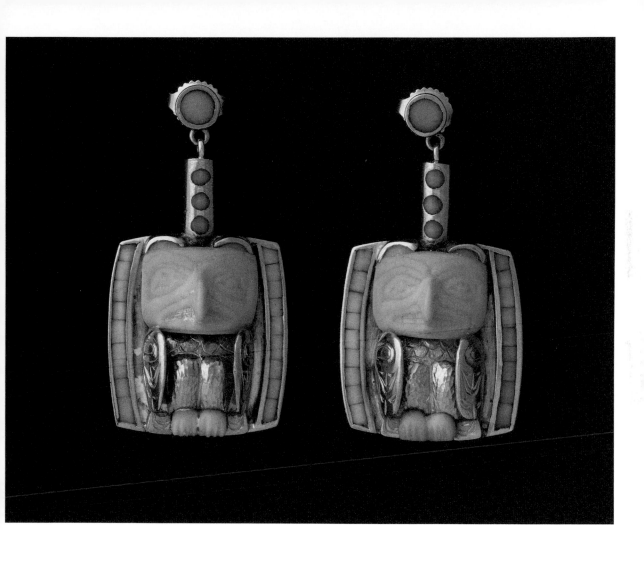

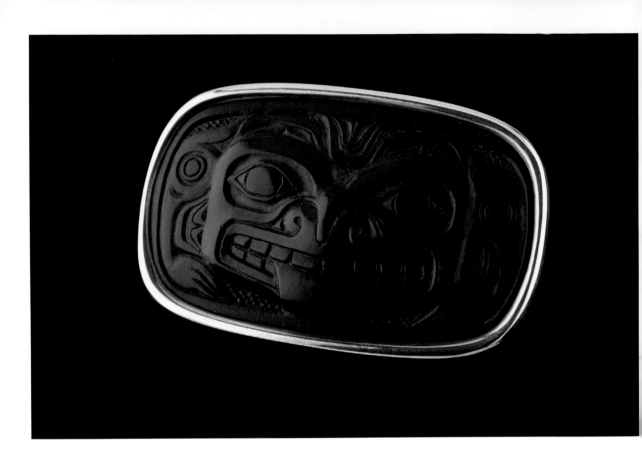

Grizzly Bear Brooch 1964

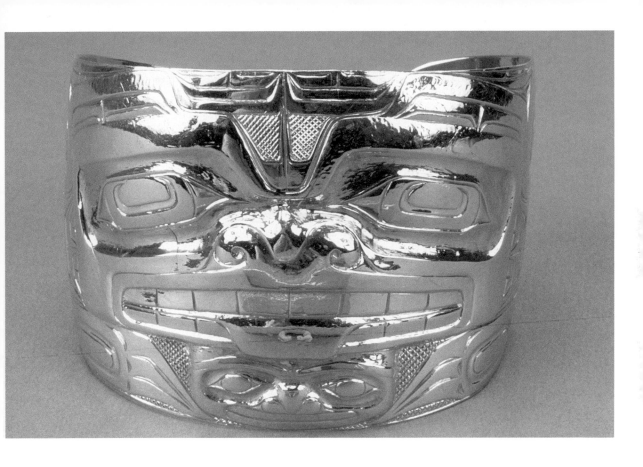

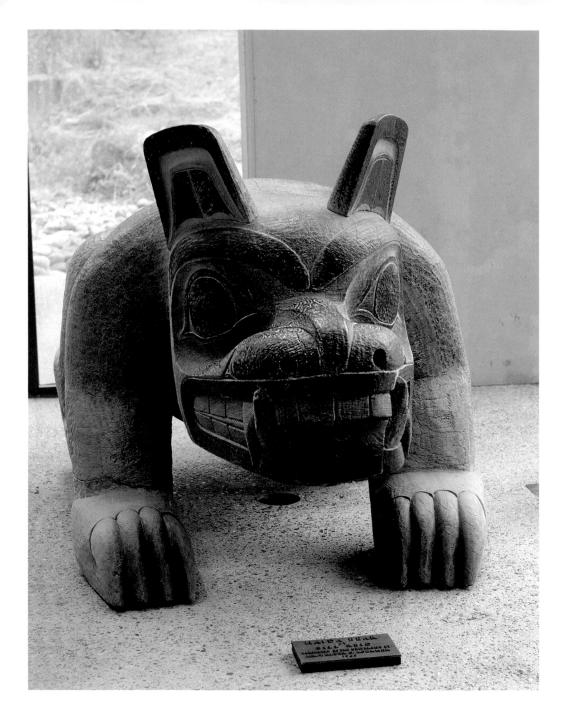

Bear Sculpture 1966

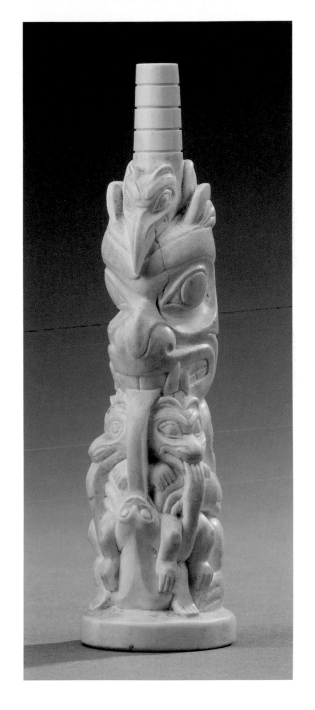

Model Totem Pole with Raven, Bear, Cubs and Frog 1966

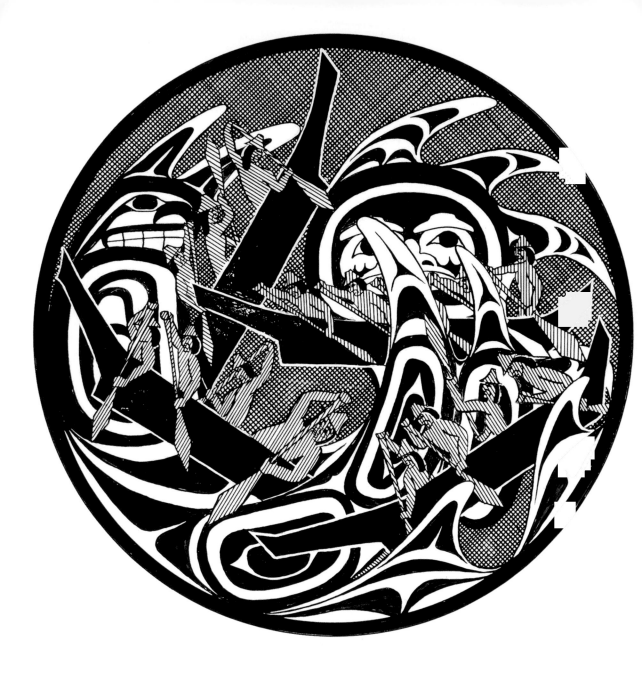

Haida Canoe in a Storm (Mixed Media) 1966

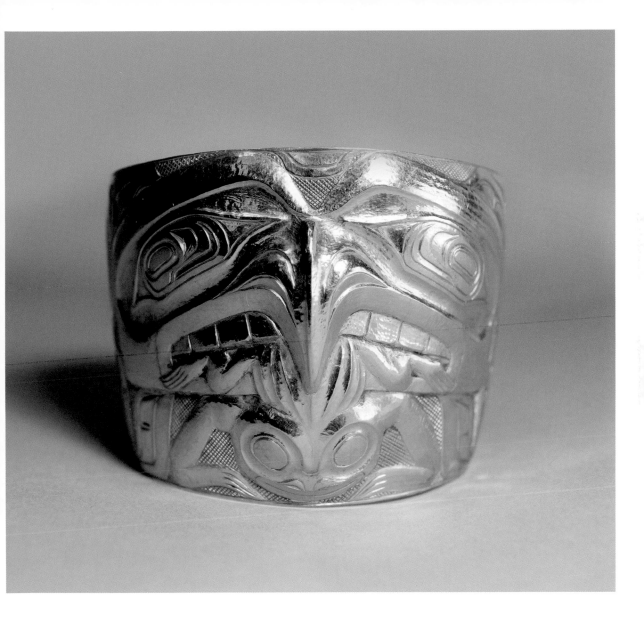

Eagle and Frog Bracelet 1967 73

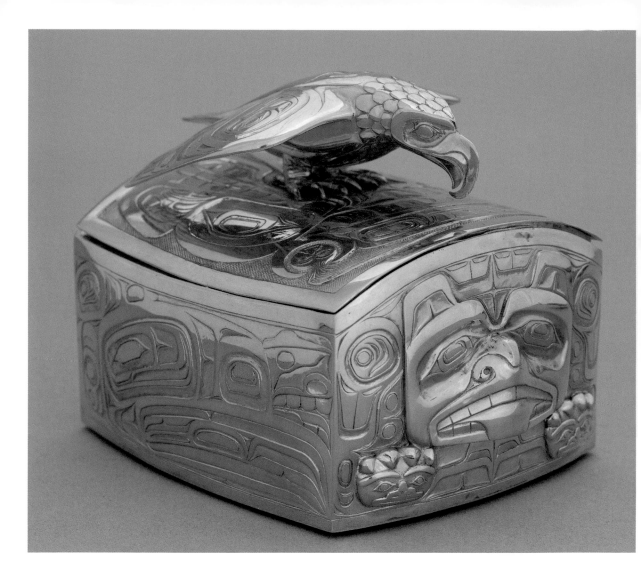

Eagle and Bear Box 1967

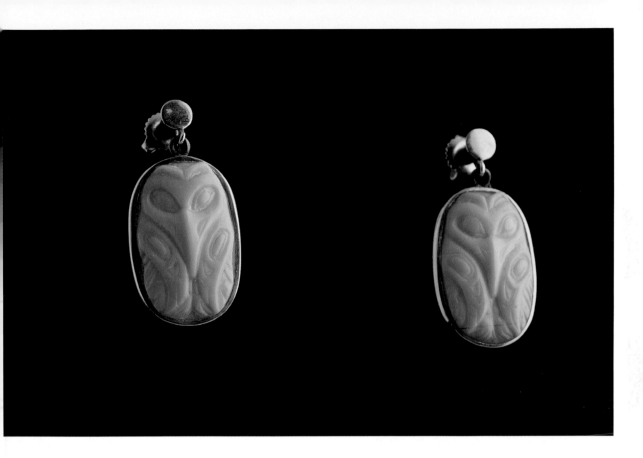

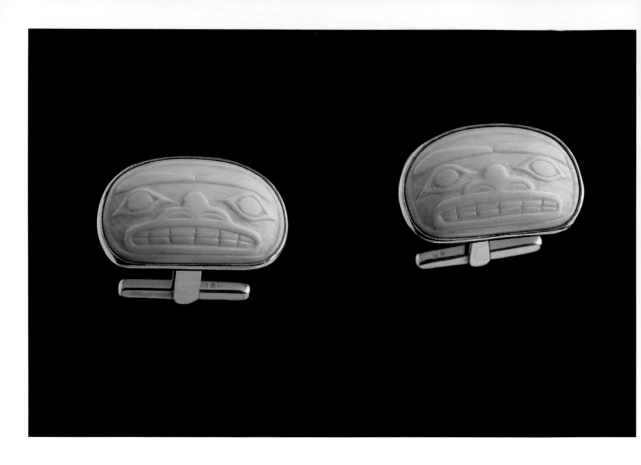

Human Face Cufflinks 1967

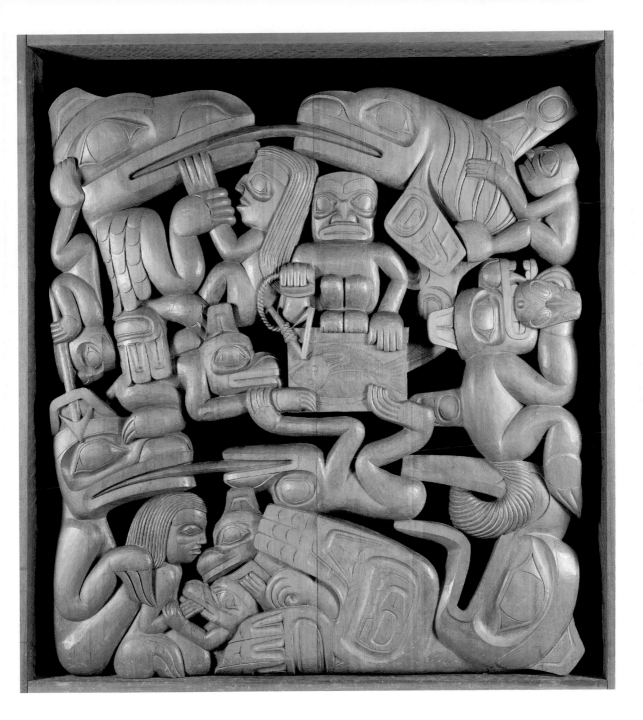

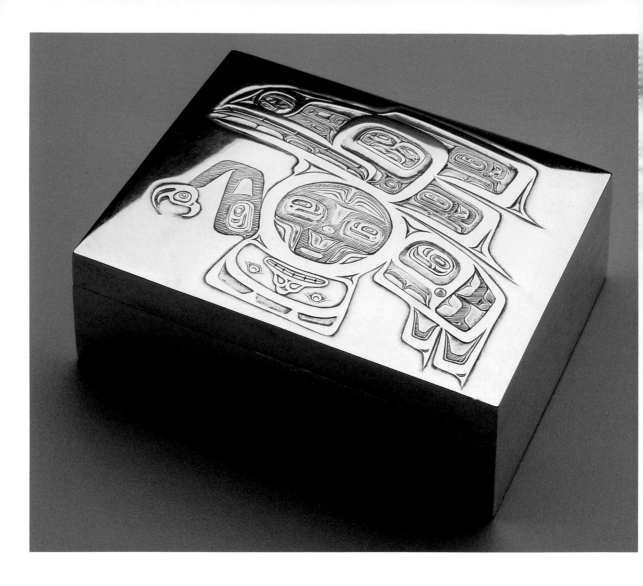

Raven Box 1969

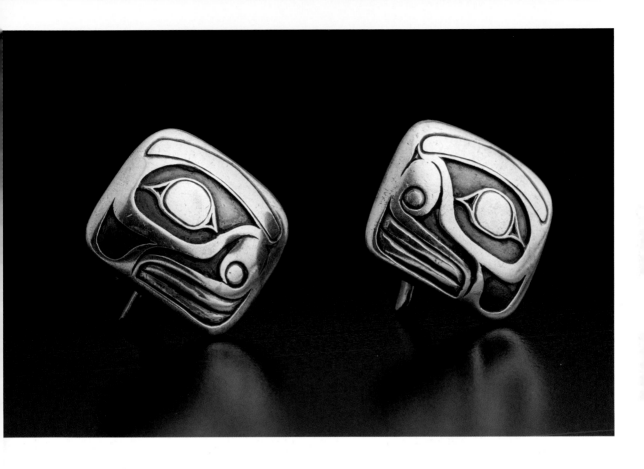

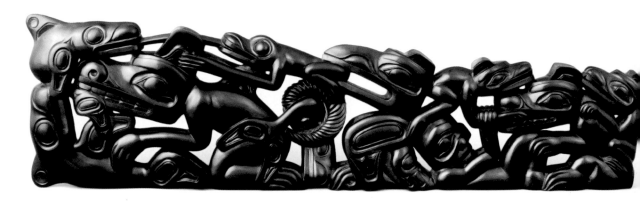

80 **Panel Pipe** 1969

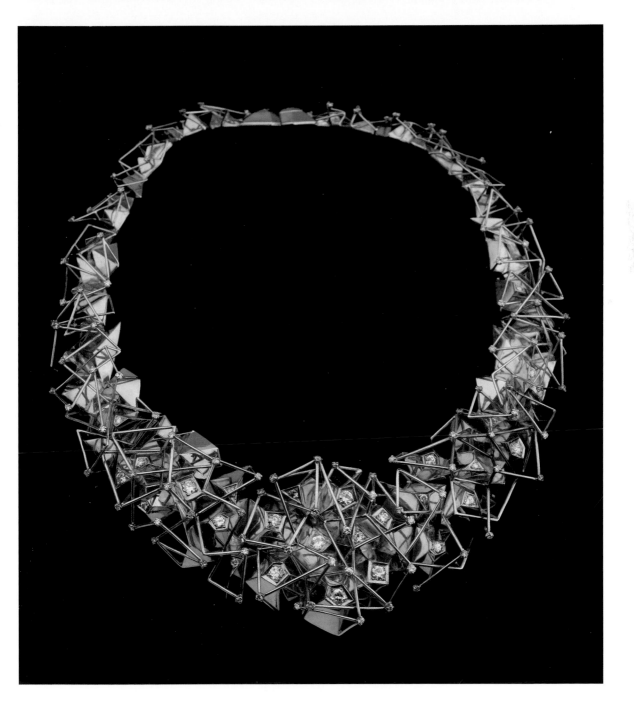

Milky Way Necklace 1969 81

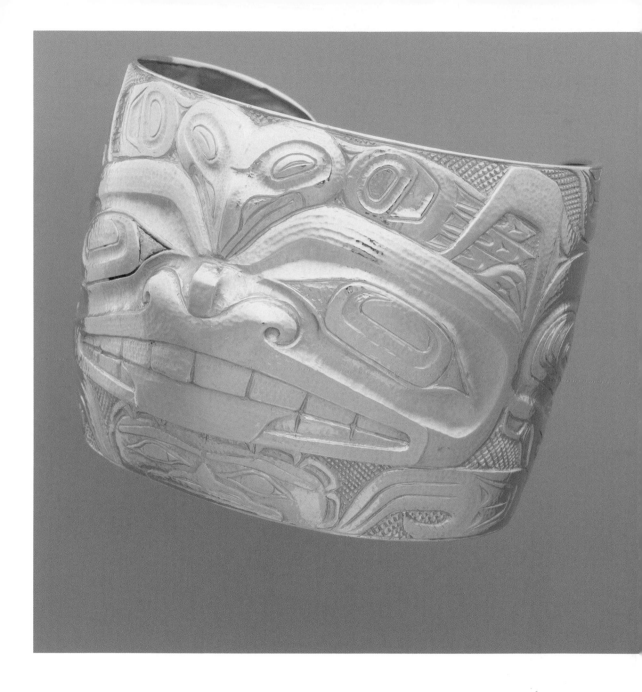

Wolf and Raven Bracelet 1969

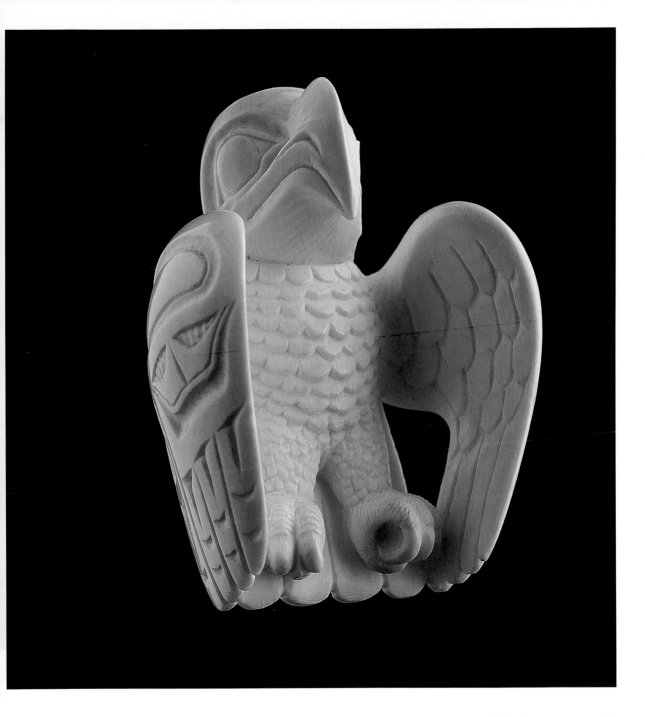

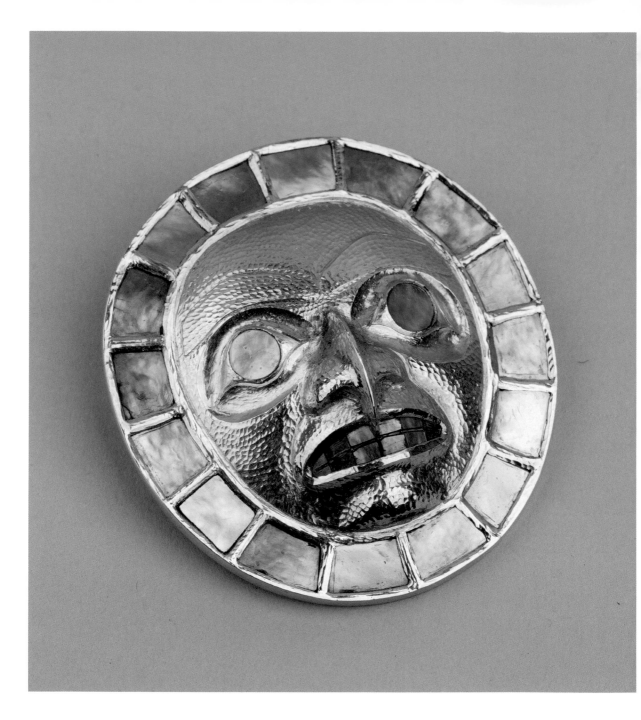

84 **Hawk Moon Pendant** c. 1970

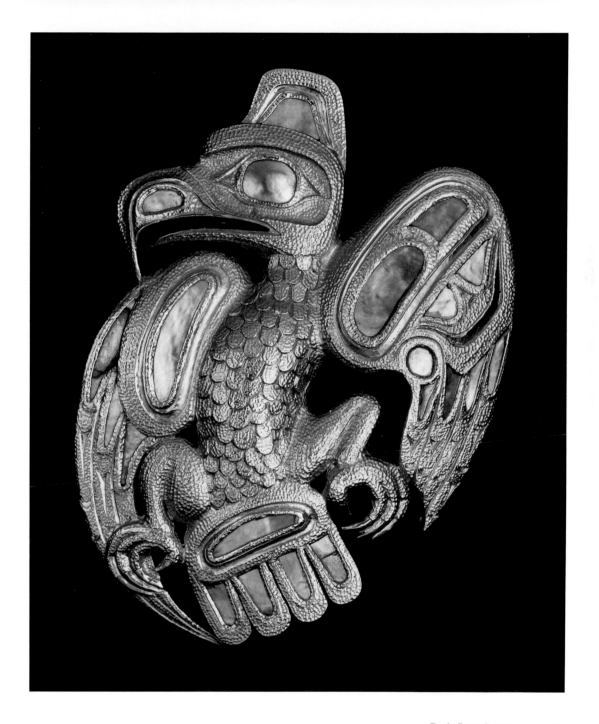

Eagle Brooch 1970 85

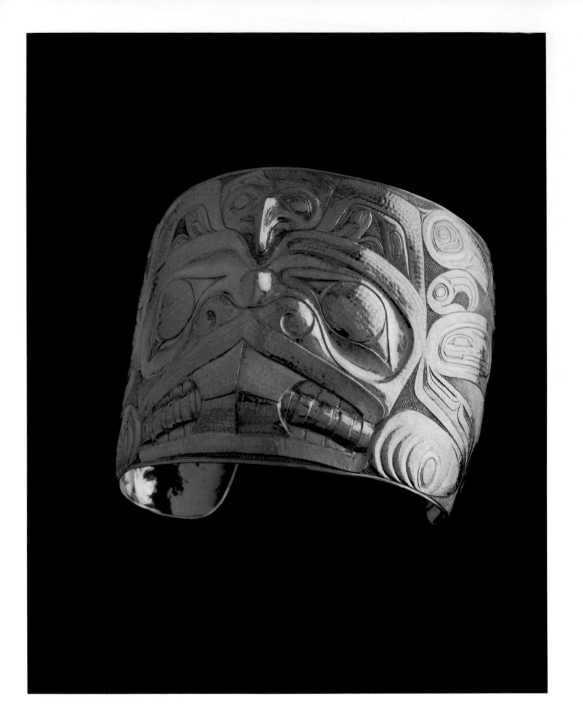

Beaver and Eagle Bracelet 1970

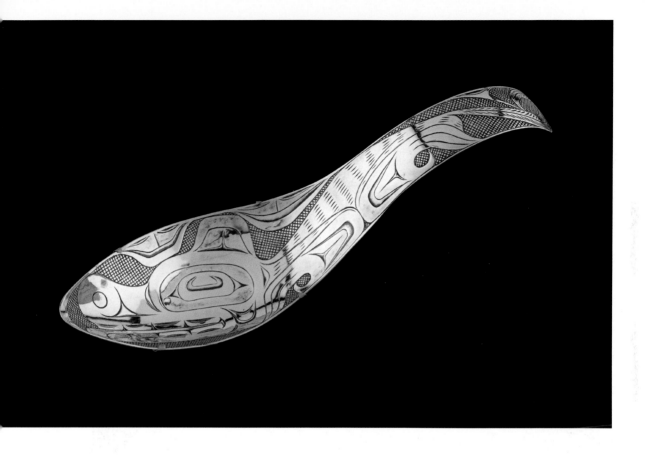

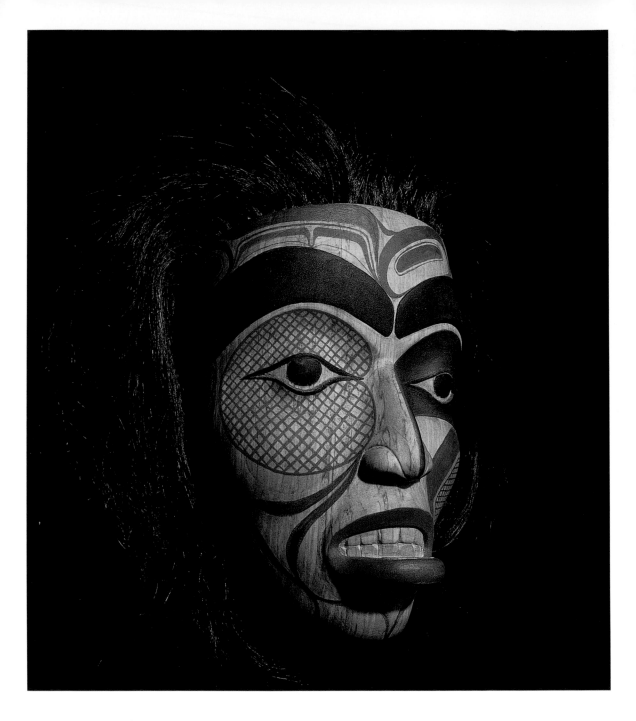

Mask of a Woman 1970

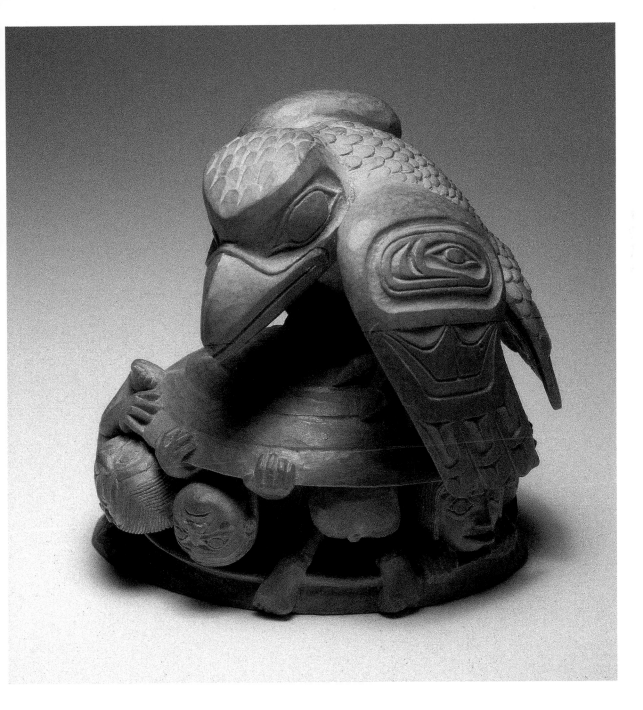

The Raven Discovering Mankind in a Clam Shell 1970　89

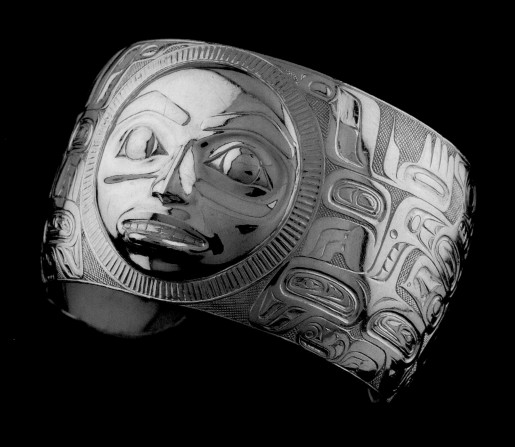

Nanasimgit Bracelet 1971

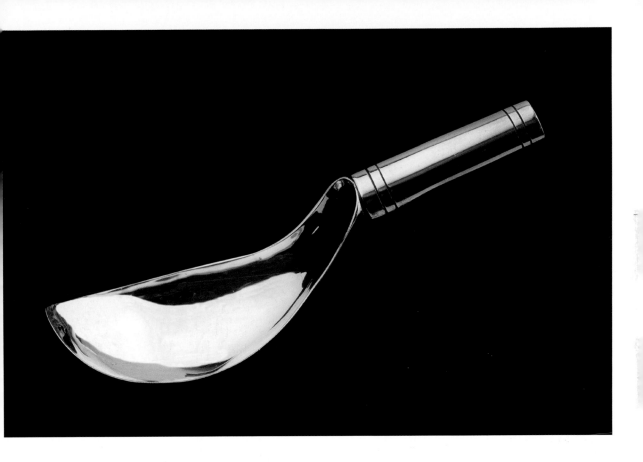

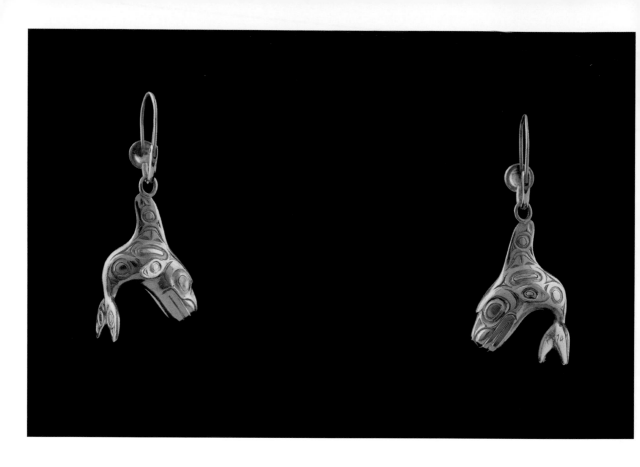

Killer Whale Earrings 1971

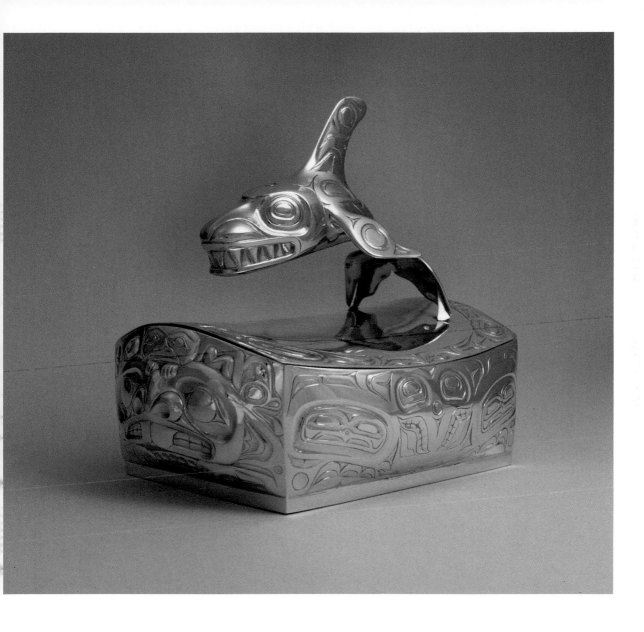

Killer Whale Box with Beaver and Human 1971 93

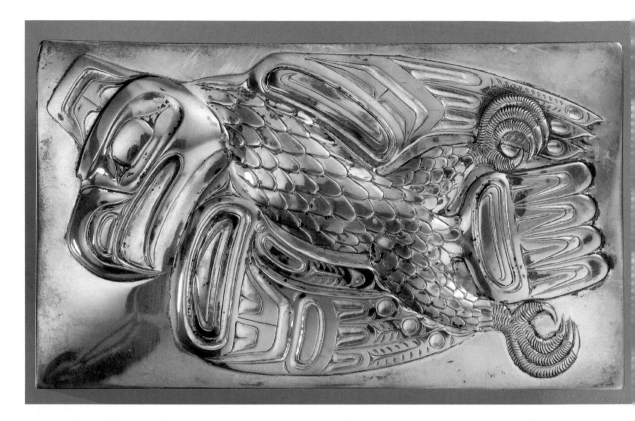

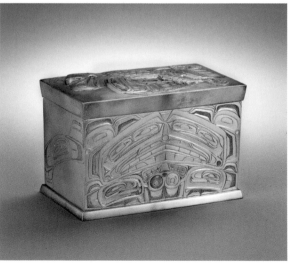

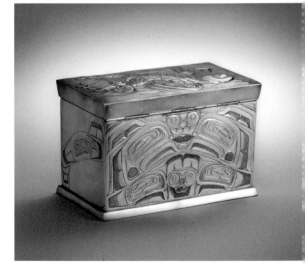

Eagle Box with Hinged Lid 1971

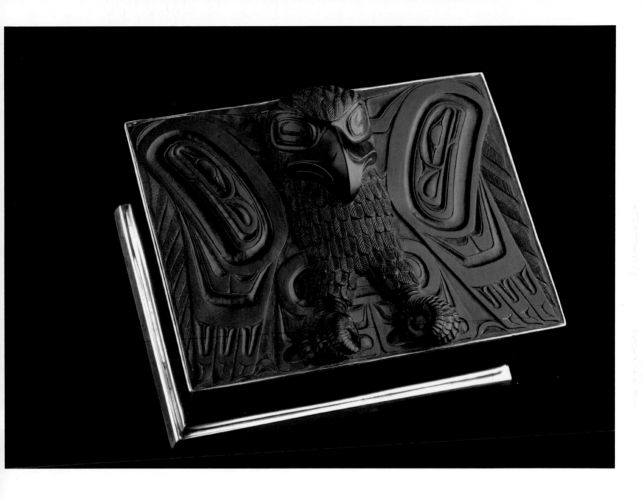

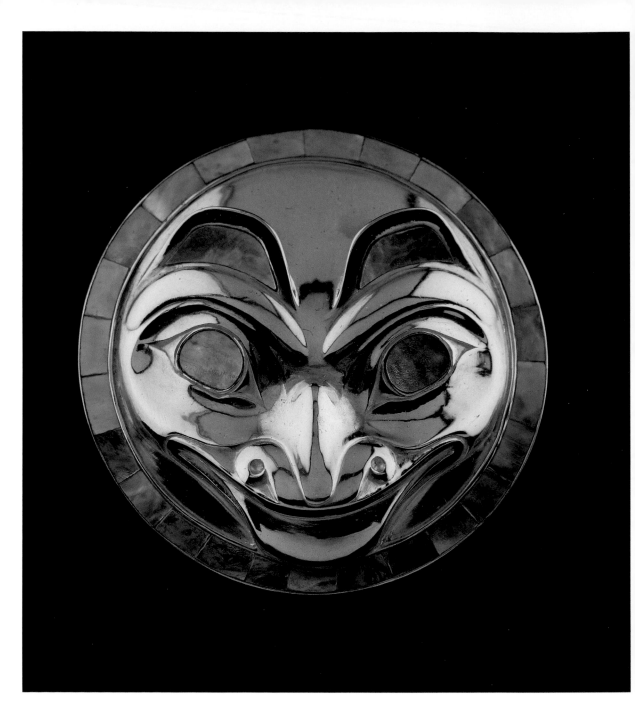

Grizzly Bear Pendant/Brooch 1972

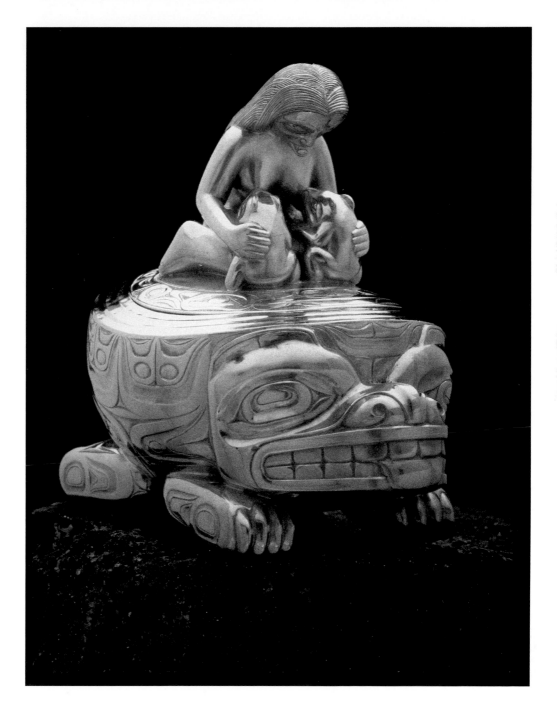

Haida Myth of Bear Mother Dish 1972

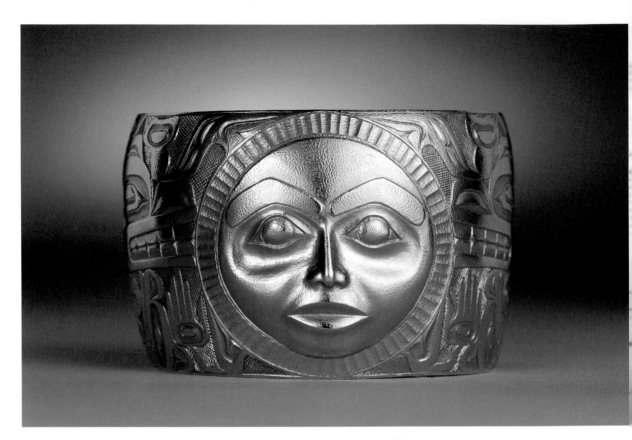

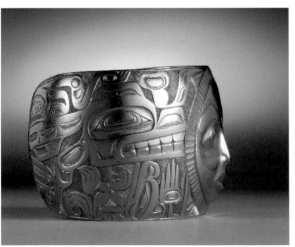

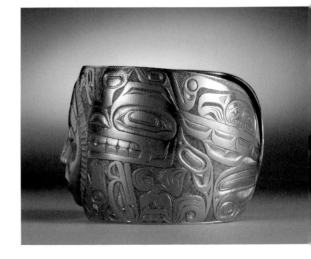

Moon Mask Bracelet 1972

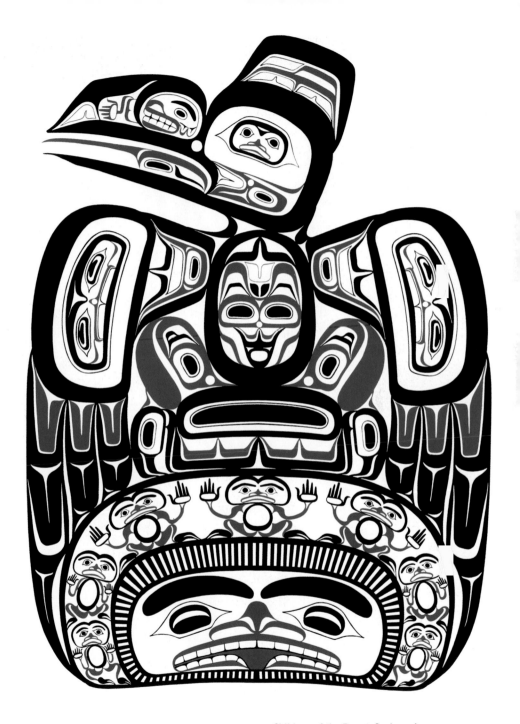

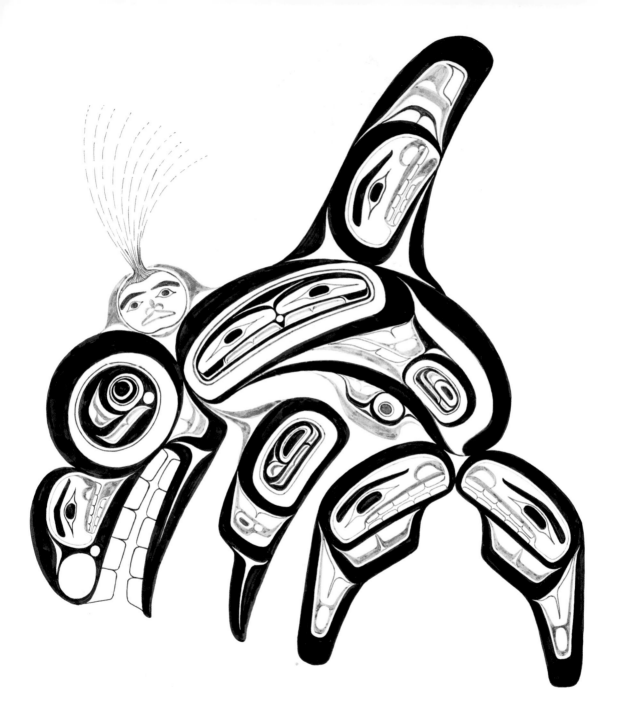

Killer Whale Painting 1973

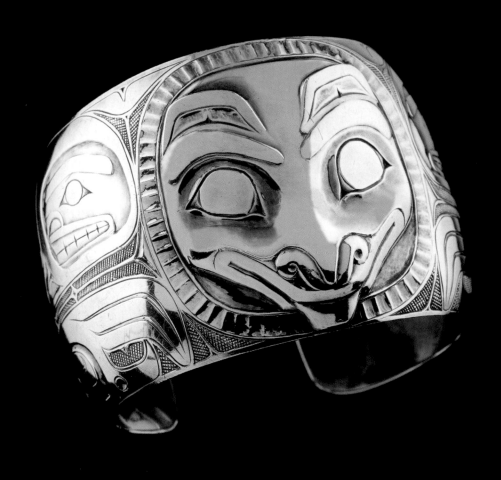

Bear Bracelet 1975

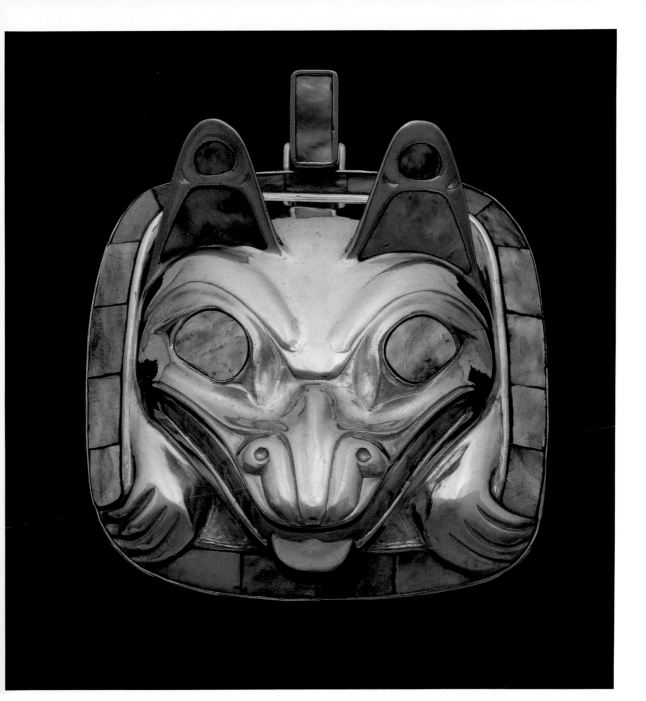

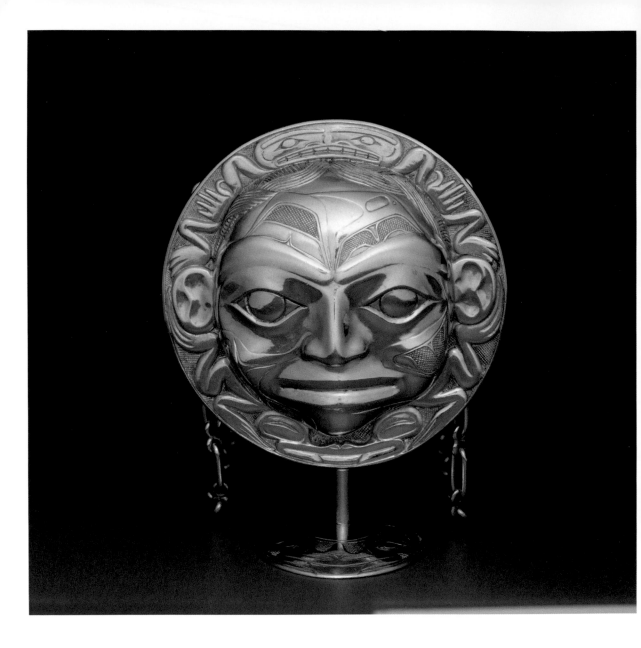

Pendant with Human Face, Chain and Pedestal 1976

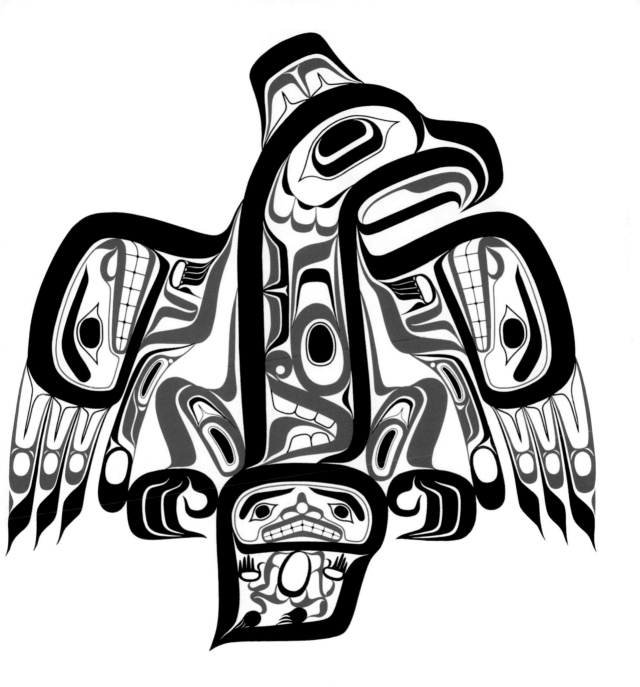

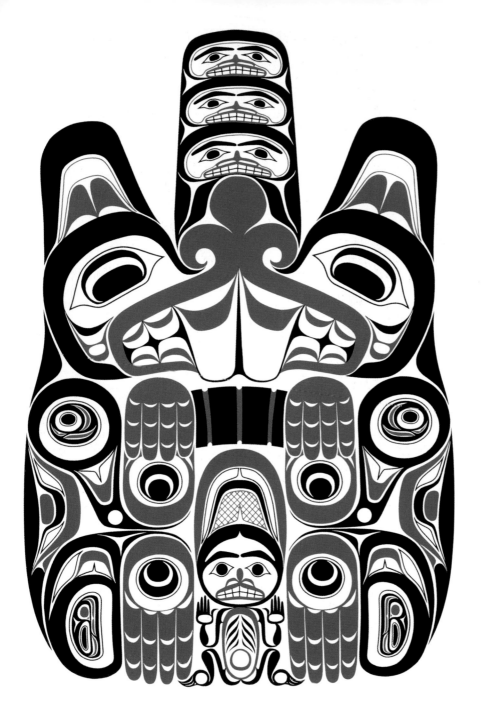

Haida Beaver—*Tsing* Serigraph 1978

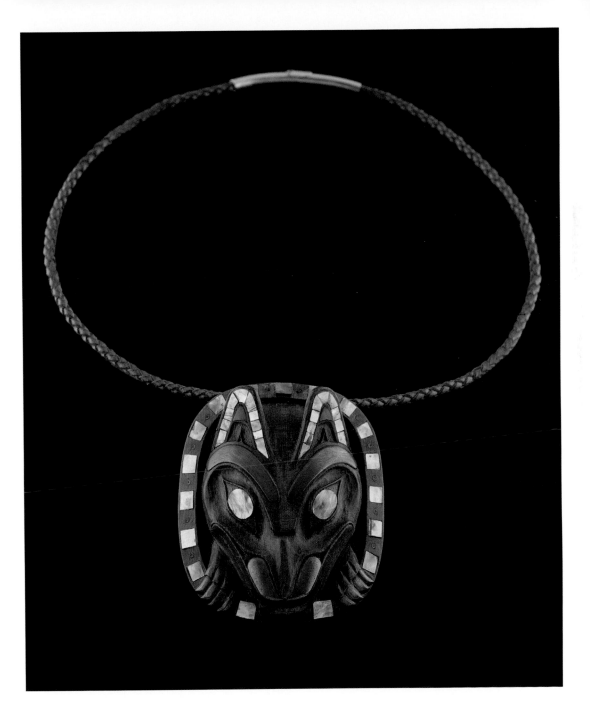

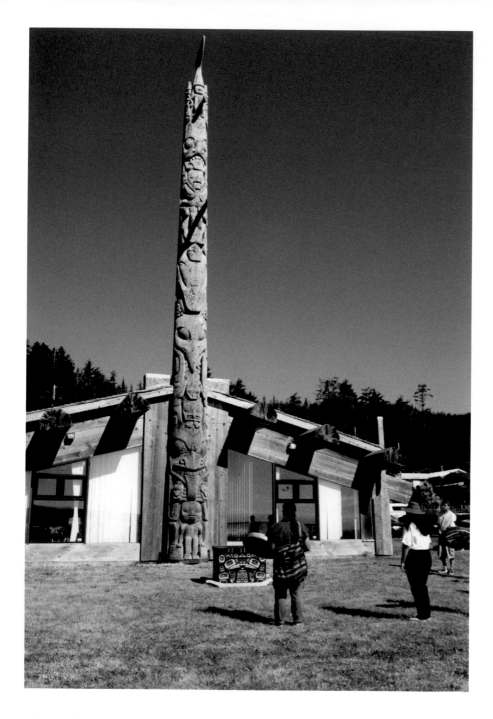

Skidegate House Frontal Pole 1978

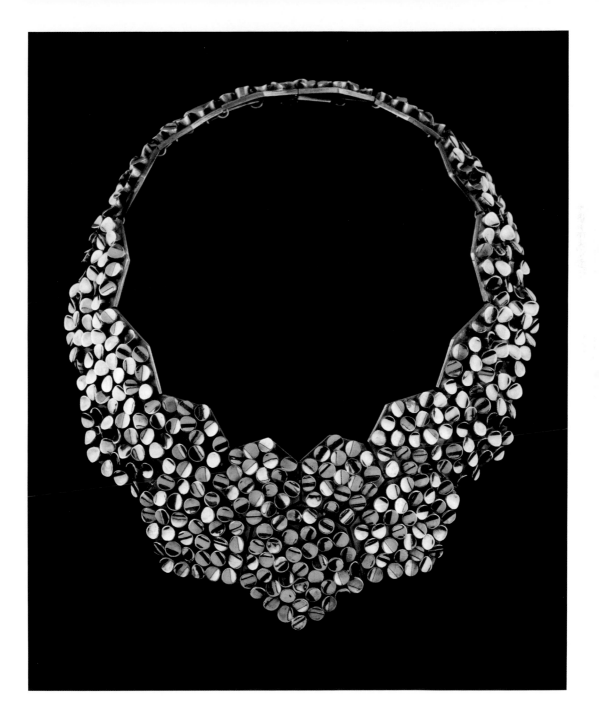

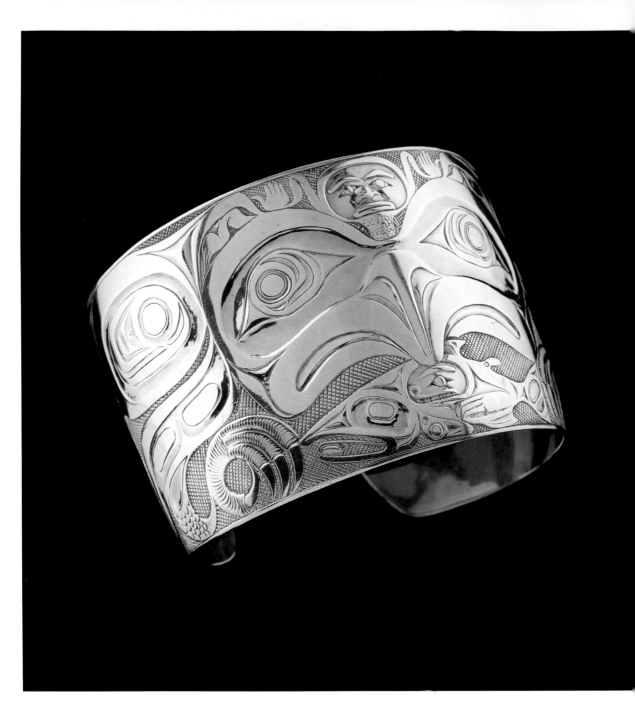

Eagle, Salmon, Bearded Man Bracelet 1979

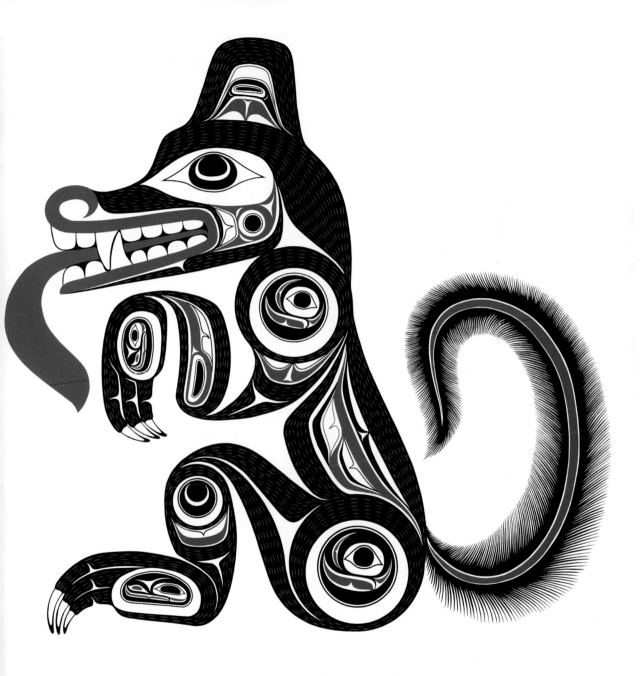

Haida Wolf—*Godji* Serigraph 1979 III

Nanasimgit Wall Hanging 1980

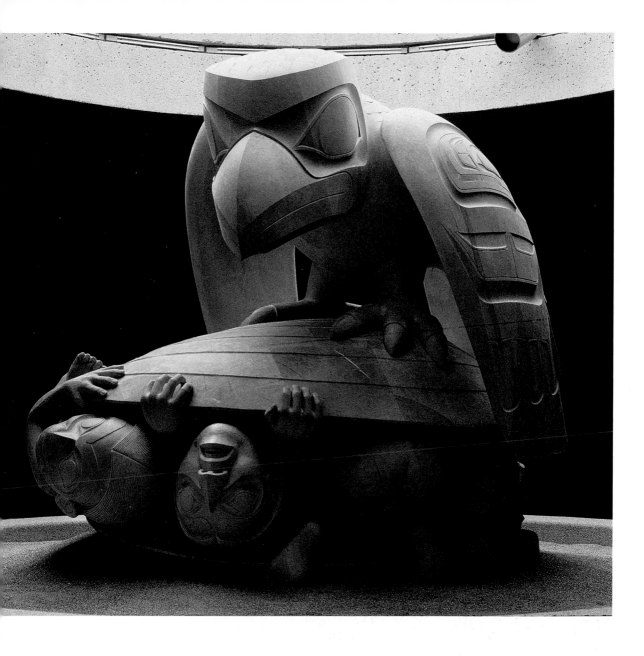

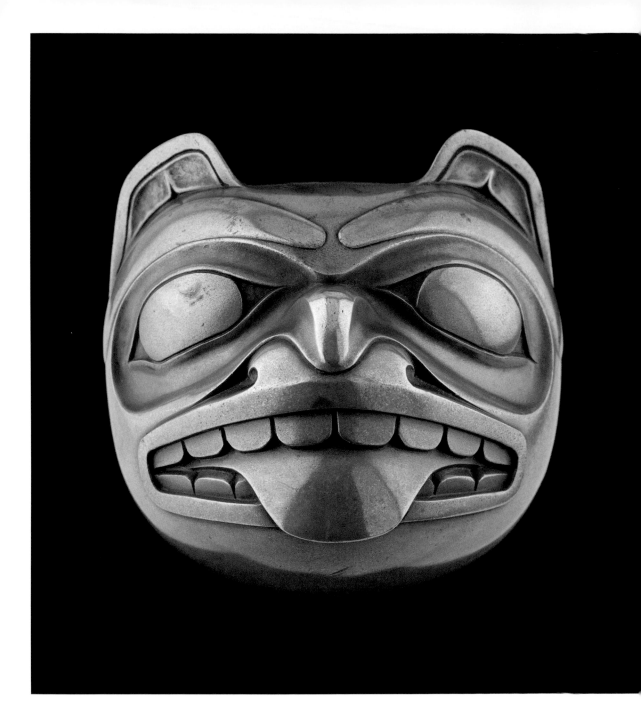

Bear Head 1981

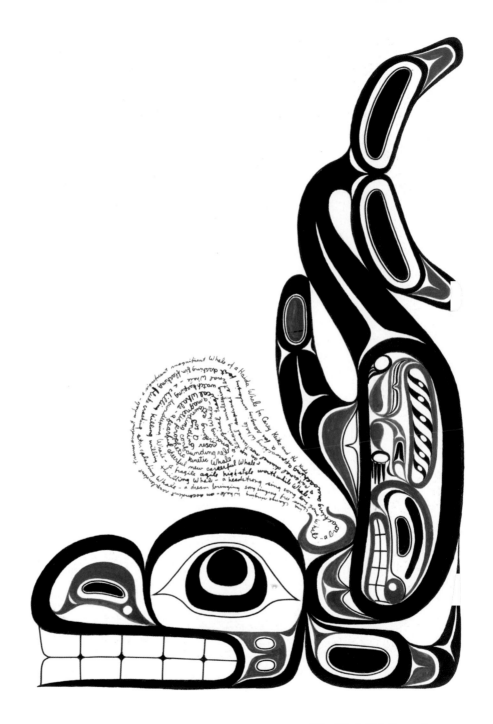

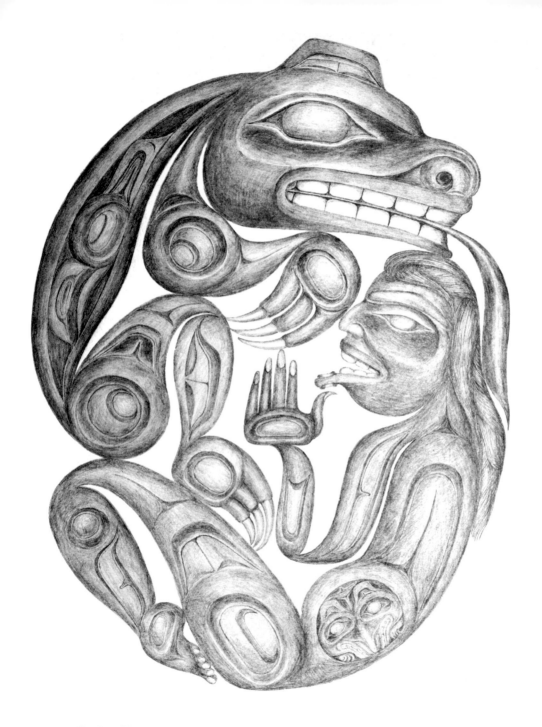

The Bear Mother and Her Husband Drawing 1982

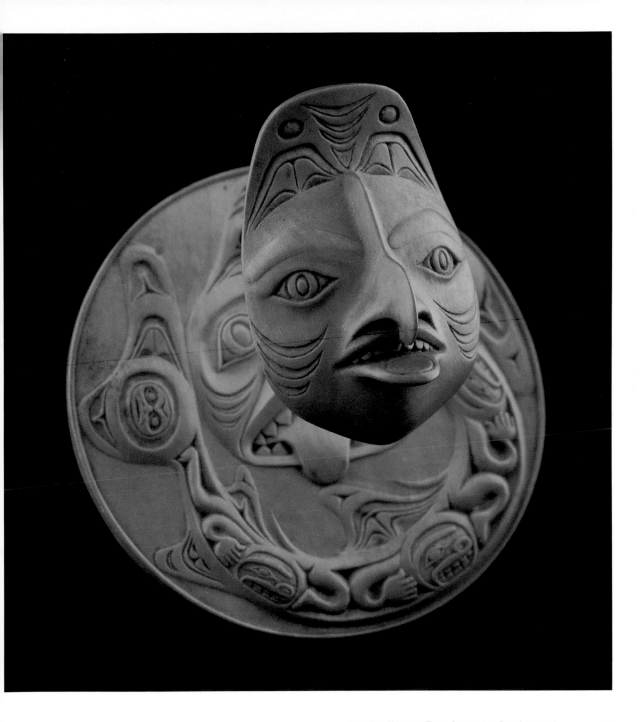

Dogfish Woman Transformation Pendant 1982 117

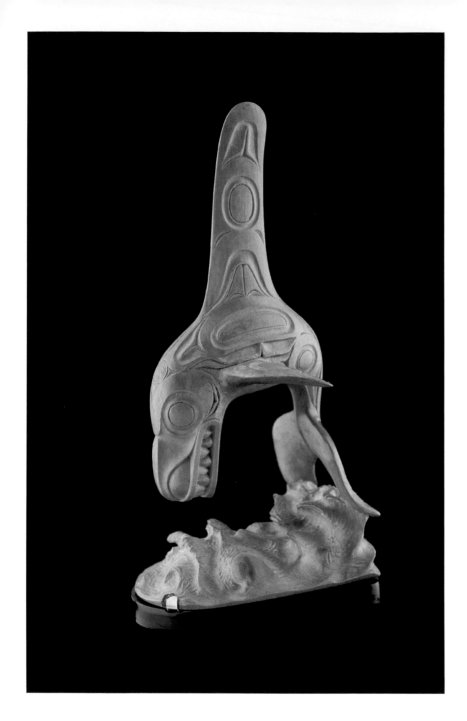

Killer Whale 1983

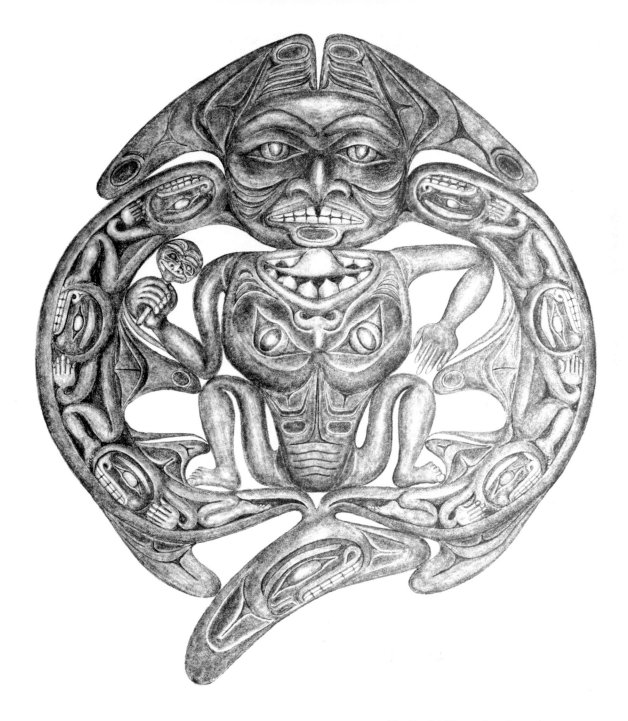

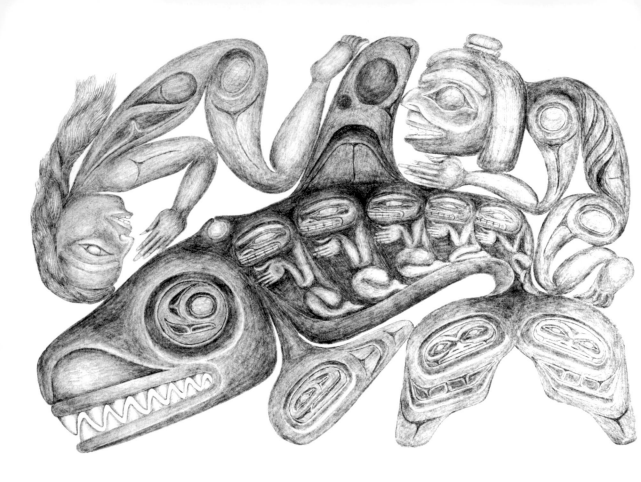

Nanasimgit and His Wife Drawing 1983

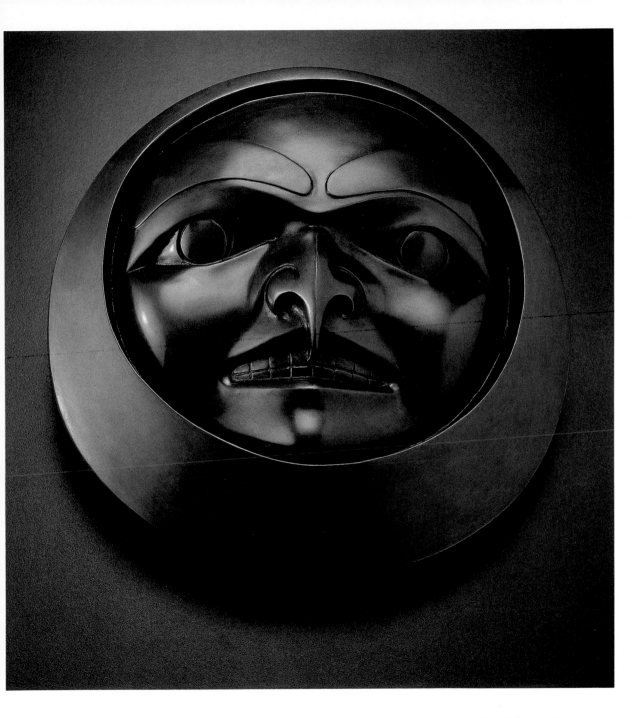

Killer Whale Spirit 1983 121

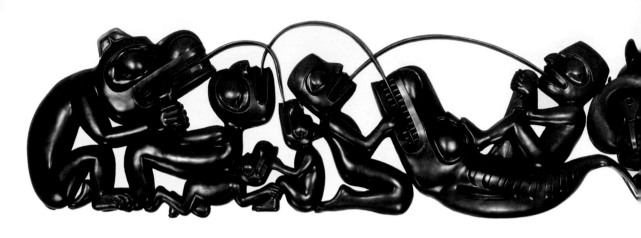

Mythic Messengers 1984

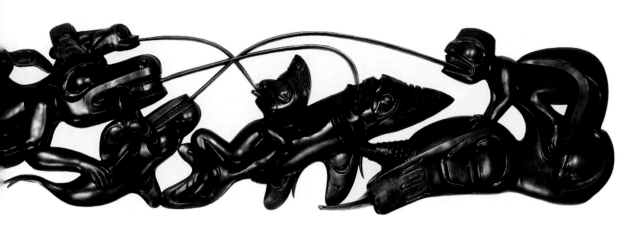

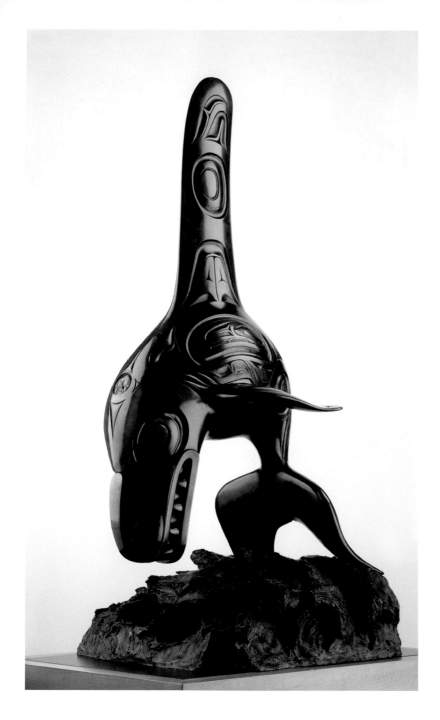

Killer Whale on Wave Base 1984

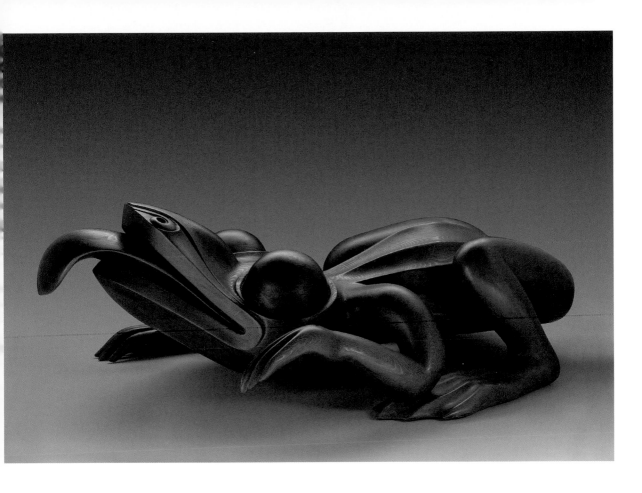

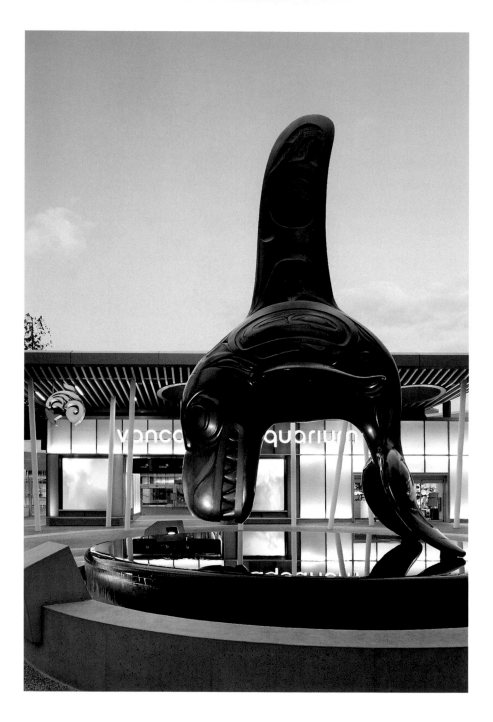

Skaana—Killer Whale, Chief of the Undersea World 1984

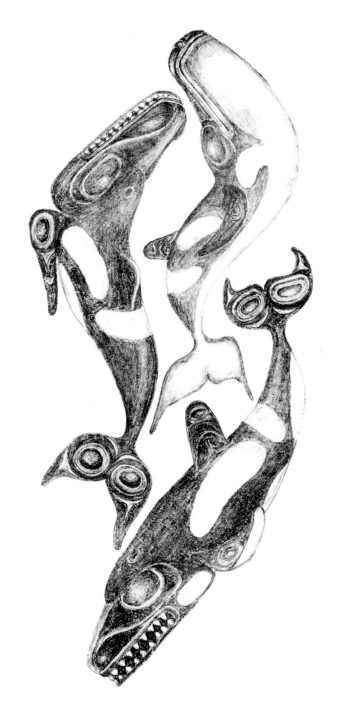

Three Whales for South Moresby Lithograph 1986　　127

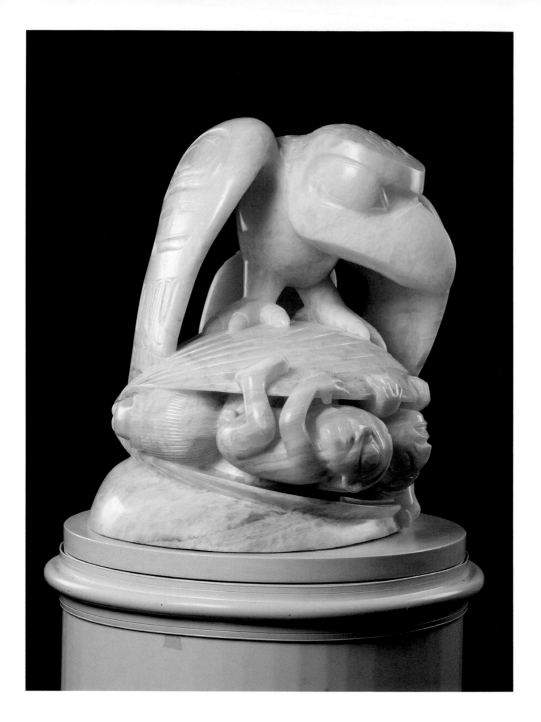

The Raven and the First Men in Onyx 1986

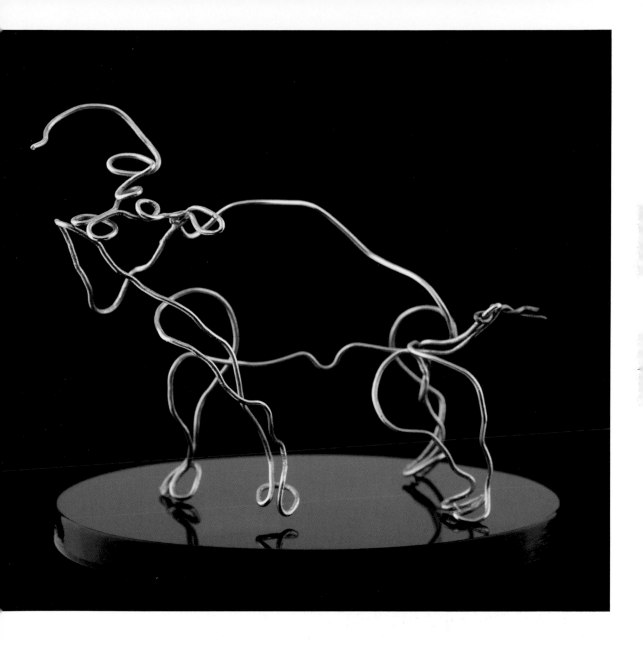

Bull Wire Sculpture 1986 129

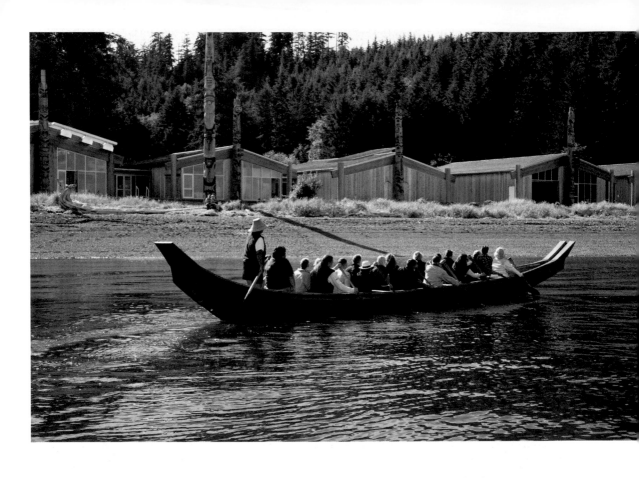

***Lootaas,* Wave Eater** 1986 (photo with crew in Haida Gwaii taken in 1989)

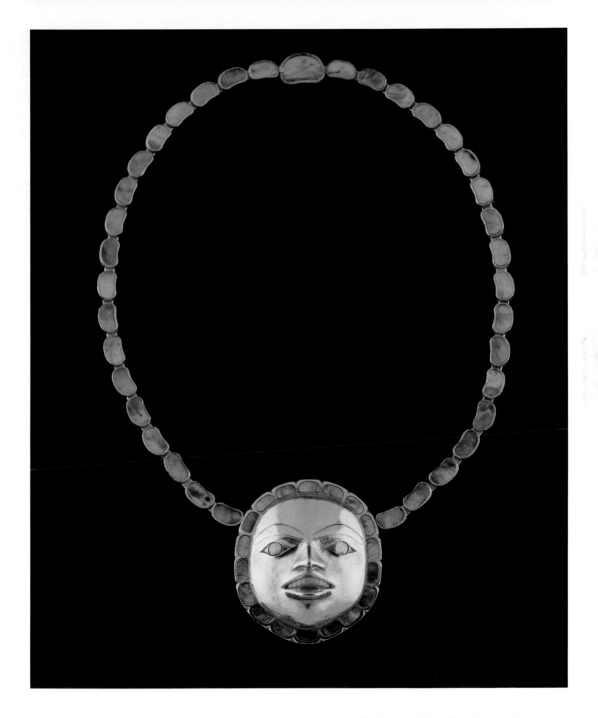

Wealth Sound Lady Necklace 1988

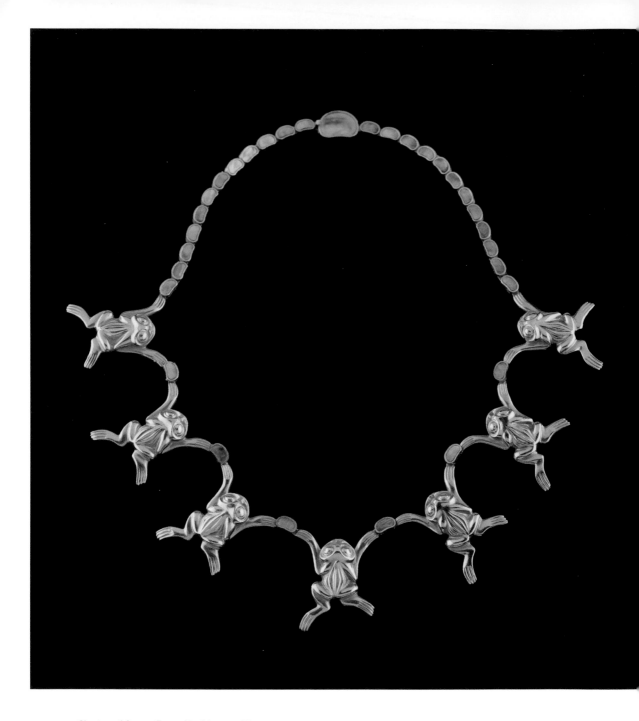

Cluster of Seven Frogs Necklace 1988

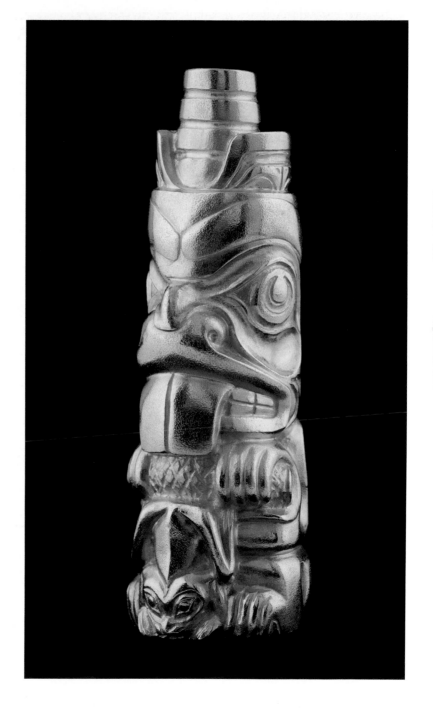

Haida Beaver Pole 1990

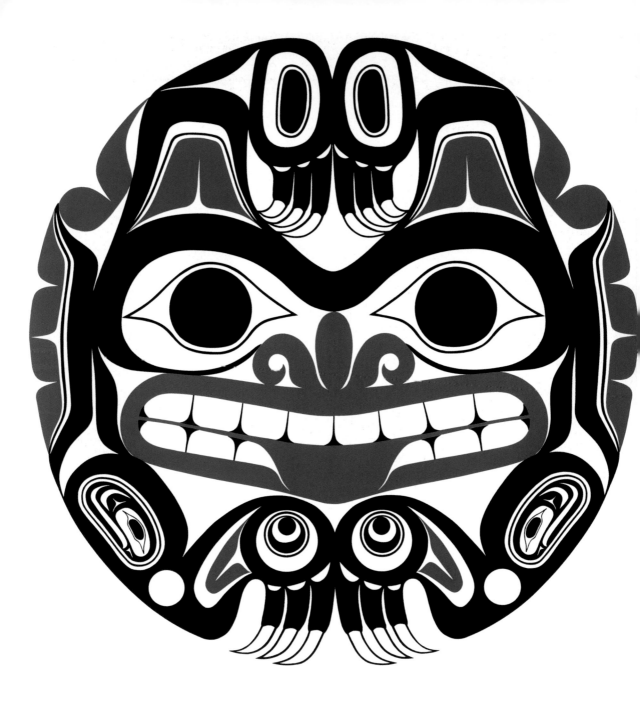

Xhuwaji—Haida Grizzly Bear Seriraph 1990

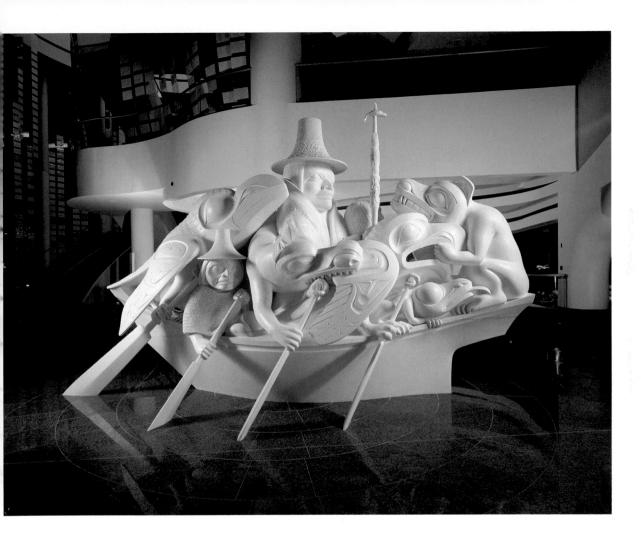

The Spirit of Haida Gwaii Maquette 1990

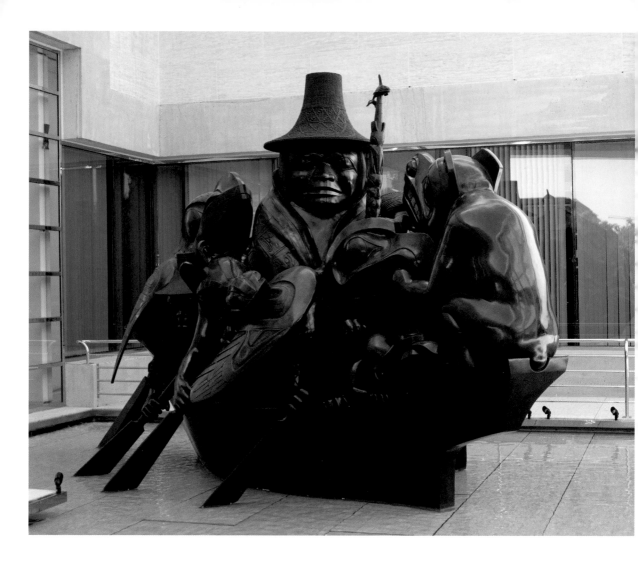

The Spirit of Haida Gwaii, The Black Canoe 1991

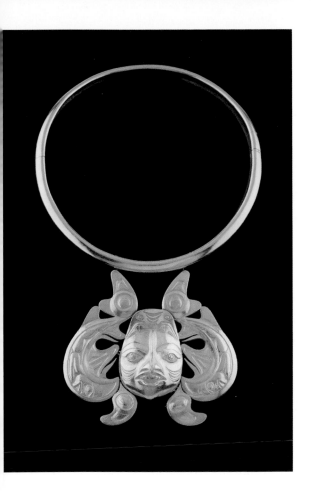

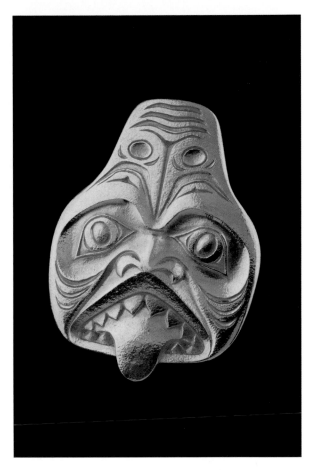

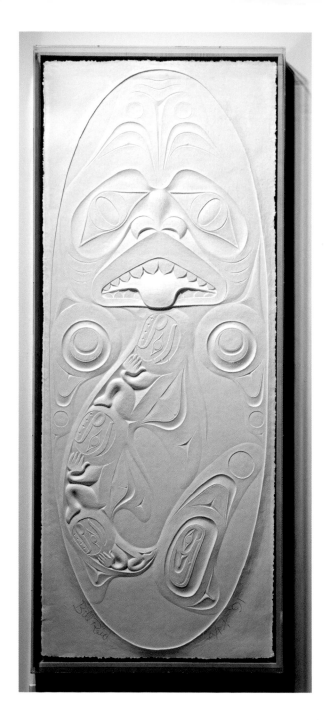

Dogfish Mural Paper Cast 1991

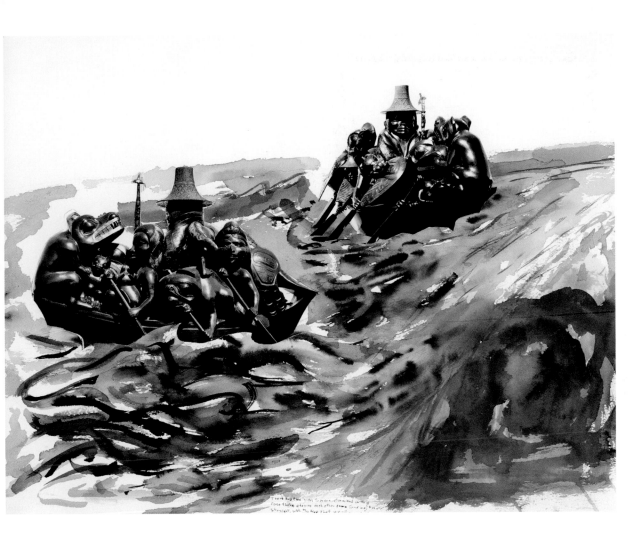

There Are Two Sides to Every Story Collage 1991 139

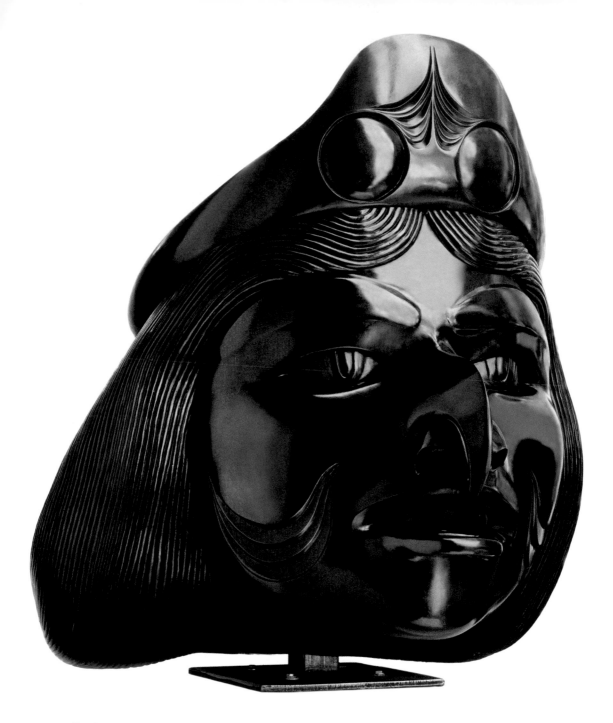

Dogfish Woman 1991

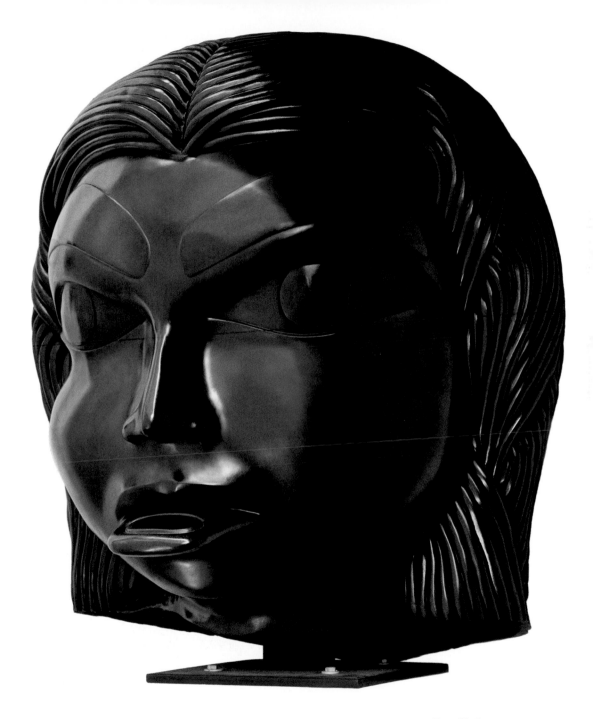

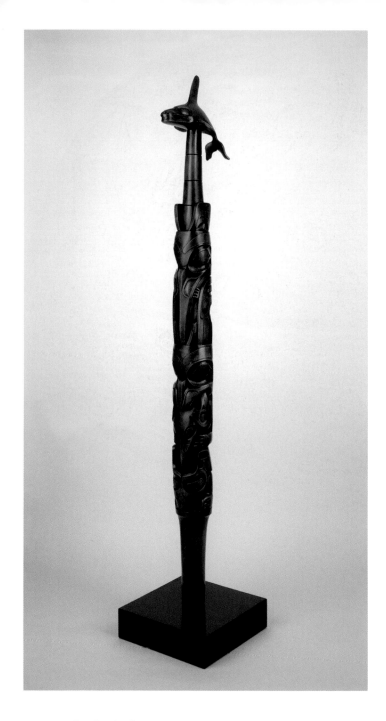

Speaker Staff 1991

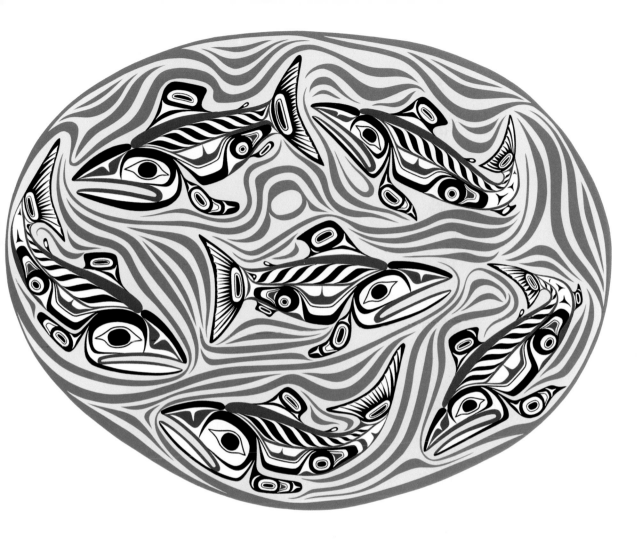

Swg'ag'ann—Sockeye Salmon Pool Serigraph 1991

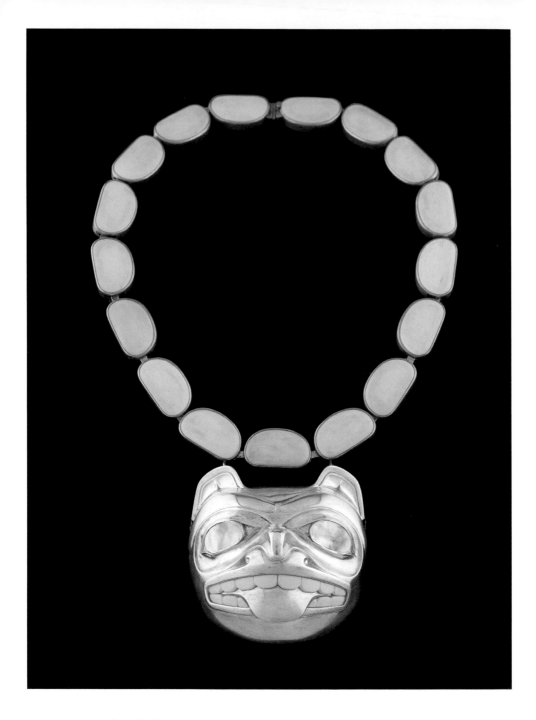

Grizzly Bear Necklace 1992

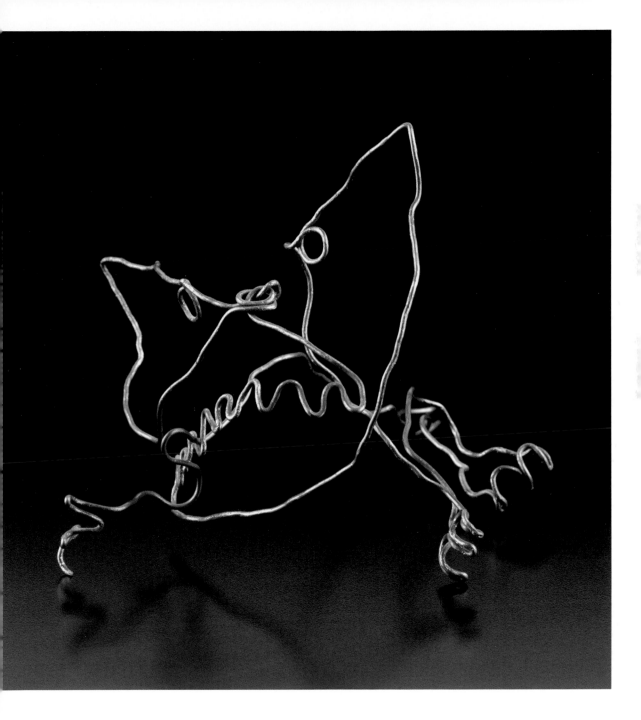

Cat Wire Sculpture c. 1993 145

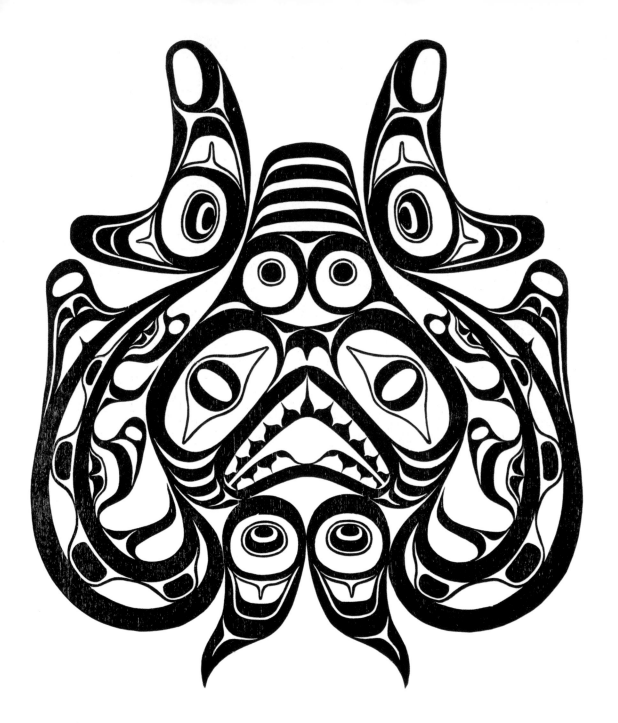

Xaxada—Haida Dogfish Woodcut 1993

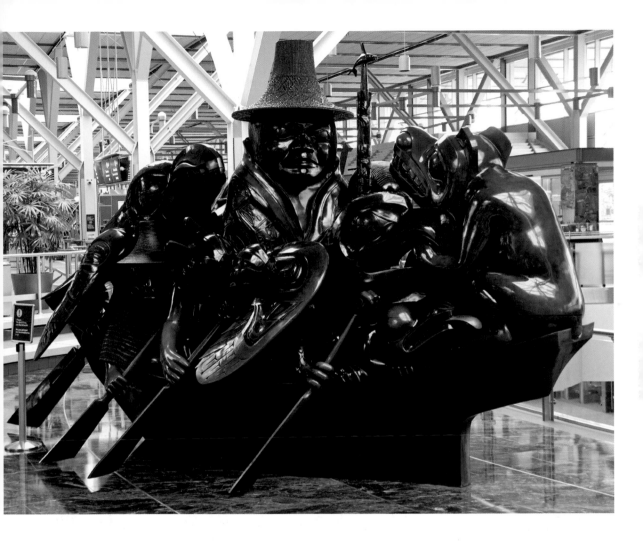

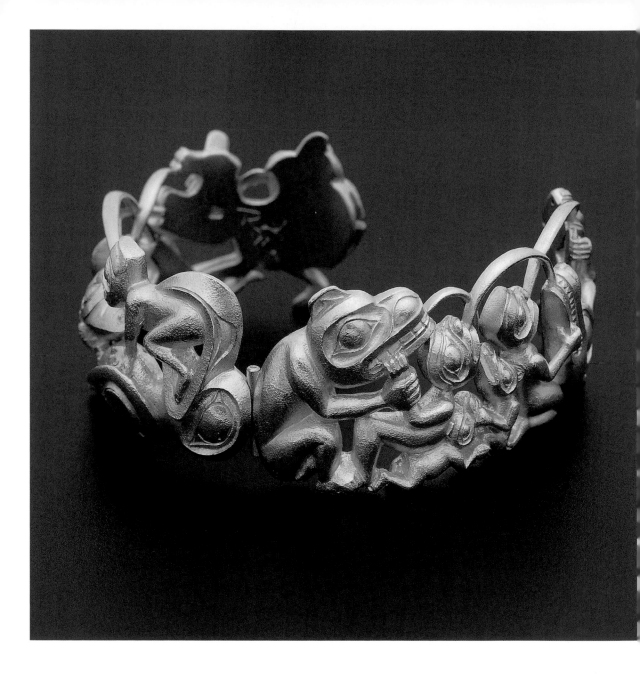

Mythic Messengers Bracelet 1994

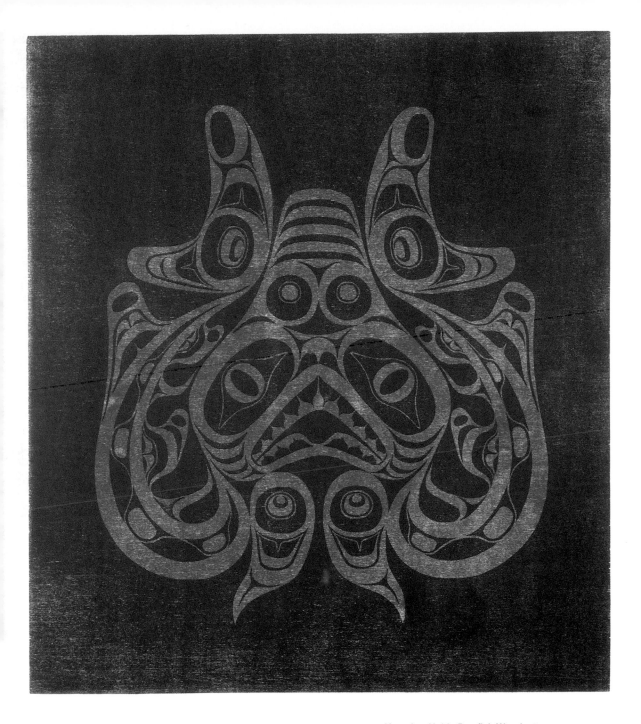

Haida Beaver Totem Pole Etching 1997

Haida Beaver Totem Pole Etching 1997 151

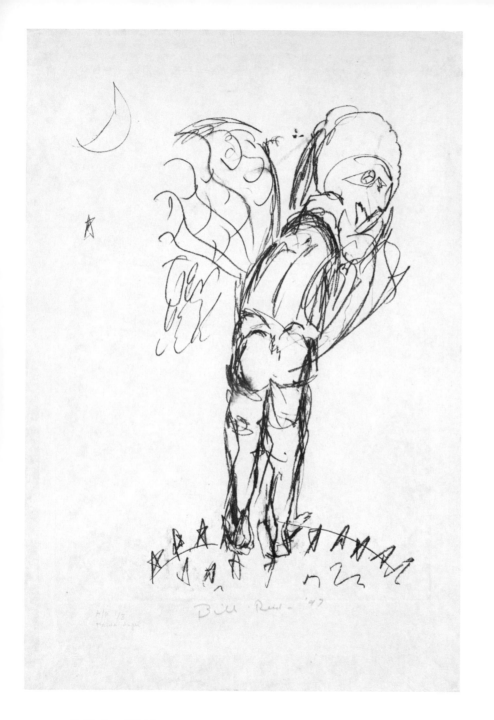

Haida Angel Etching 1997

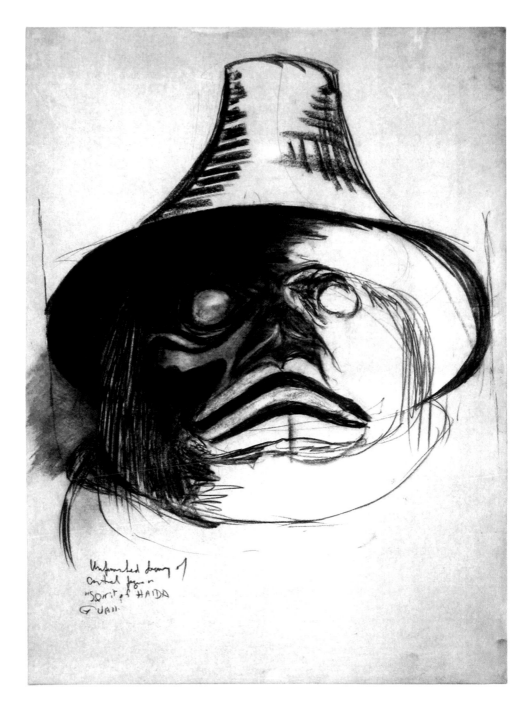

Unfinished drawing of
Central figure in
"Spirit of HAIDA
GWAII"

Unfinished Drawing of Central Figure of the Spirit of Haida Gwaii Etching 1997

List of Works

Miniature Tea Set, page 27. c. 1932, blackboard chalk, nail polish, teapot 2.2 cm W, creamer jug 0 .7 × 1.1 cm; sugar bowl 0.7 × 1 cm; handle to handle, 0.3 cm D, Bill Reid-SFU Art Collection, Gift of Dr. Margaret (Peggy) Kennedy, BRF #143. Photo Credit: Kenji Nagai.

Ruby Ring, page 28. c. 1948, platinum, diamond and ruby, Private collection. Photo Credit: Kenji Nagai.

Sxwaixwe **Mask Pendant**, page 29. 1954, silver, 6.7 × 4.4 × 1.5 cm, Owned by a member of the *Sxwaixwe* family at Musqueam who wishes to remain anonymous. Photo Credit: Kenji Nagai.

Woman in the Moon Pendant/Brooch, page 30. 1954, sterling silver, after a tattoo design by Wi'ha, 5 cm D, Private collection. Photo Credit: Courtesy of Douglas Reynolds Gallery.

Cufflinks, page 31. c. 1955, sterling silver, 3.2 × 1.9 cm, Private collection, Courtesy of Miriam Shiell Fine Art, Toronto. Photo Credit: Bill McLennan.

Hinged Raven Bracelet, page 32. c. 1955, 22k gold, UBC Museum of Anthropology, Gift of Dr. Sydney Friedman and Dr. Constance Livingstone-Freidman, 2923/1. Photo Credit: Kila Balley.

Killer Whale Brooch, page 33. c. 1955, sterling silver, 4.45 L × 2.38 cm W, Bill Reid-SFU Art Collection, Gift of Doris Shadbolt, BRF #115. Photo Credit: Kenji Nagai.

Haida Bear Brooch, page 34. c. 1955, sterling silver, 6.8 × 4 cm, Private collection. Photo Credit: Kenji Nagai.

Bear Mother Story Silver Engraving Block, page 35. c. 1955, silver, 18.8 cm H × 19.7 cm W, Private collection. Photo Credit: Kenji Nagai.

Bear Mother Engraving, page 36. 1955/1989, silver engraving, printed in 1989 by the Barbarian Press with the 1955 silver engraving block, 18.8 × 19.7 cm, Bill Reid-SFU Art Collection, Gift of Dr. Martine Reid, BRF #106. Photo Credit: Kenji Nagai.

Dogfish Woman Pendant, page 37. c. 1956, sterling silver, 6 cm D, Courtesy of Douglas Reynolds Gallery, Private collection.

Pendant with Raven and Whale Tattoo Designs. Based on a Drawing by Charles Edenshaw, page 38. 1956, sterling silver, 4.9 × 4.5 × 0.6 cm, Royal BC Museum and Archives, Victoria, #17164.

Tschumos **Dish**, page 39. 1956, argillite, 6 × 9.8 × 2 cm, Bill Reid-SFU Art Collection, Gift of Dr. Martine Reid, BRF #05. Photo Credit: Kenji Nagai.

Tschumos **Brooch**, page 40. c. 1956, sterling silver, 3.9 × 6.6 cm, Bill Reid-SFU Art Collection, Gift of Dr. Martine Reid, BRF #02. Photo Credit: Kenji Nagai.

Bracelet with Bear, Frog, Eagle, Man, Killer Whale, Raven, page 41. c. 1956, sterling silver with oxidized background, 3.7 cm W × 6.2 cm D, Private collection. Photo Credit: Kenji Nagai.

Hinged Gold Bracelet, page 42. 1957, 22k gold engraved, hinged, adapted from two sides of an argellite house model, 4 cm W, Private collection. Photo Credit: Kenji Nagai.

Dogfish Brooch, page 43. c. 1957, 22k gold, after a Charles Edenshaw tattoo design, 8.2 × 3.3 cm, Private collection. Inscribed Design—Charles Edenshaw. Photo Credit: Kenji Nagai.

Raven Earrings, page 44. c. 1957, sterling silver, 2 cm H × 0.8 cm W, Private collection. Photo Credit: Courtesy of Douglas Reynolds Gallery

Pair of Identical Bear Bracelets, page 45. c. 1958, 22k gold. Photo Credit: Courtesy of Douglas Reynolds Gallery.

Hawk Earrings, page 46. c. 1958, 22k gold, 2 cm H × 2.3 cm W, Private collection. Photo Credit: Kenji Nagai.

Grizzly Bear Mantelpiece, page 47. c. 1958, red cedar, stain, 96 × 200 × 32 cm, Royal BC Museum and Archives, Victoria. Acquisition made possible through a donation from The Audain Foundation for the Visual Arts in 2011, RBCM #20395.

Tschumos **Bracelet**, page 48. c. 1958, sterling silver, hinged, 2.6 cm W × 7.9 cm L, Private collection, Courtesy of Miriam Shiell Fine Art, Toronto, Photo Credit: Bill McLennan.

Split Eagle Bracelet, page 49. 1959, 22k gold, 1.6 cm W × 5.4 cm inside D, Bill Reid-SFU Art Collection, Gift of Toni and Hildegard Cavelti, BRF# 145. Photo Credit: Kenji Nagai.

Hoop Earrings with Mythic Narratives, page 50. c. 1960, sterling silver, 5.5 cm outside D, 4 cm inside D, Bill Reid-SFU Art Collection, Gift of Dr. Martine Reid, BRF #17. Photo Credit: Kenji Nagai.

Eagle Earrings, page 51. 1960, 22k gold, 3.1 cm L × 2.2 cm W, Private collection. Photo Credit: Kenji Nagai.

Thunderbird and Whale Brooch, page 52. 1960, sterling silver, after a Charles Edenshaw argillite plate (CMC #VII-B-824-S94-6817), Haida Art Reid, 5.5 × 4.5 × 0.3 cm, British Museum, Gift of Mrs. June Bedford in honour of Jonathan King, Courtesy of the Trustees of the British Museum, London.

Earrings, page 53. 1961, sterling silver, 2.2 cm L, Courtesy of UBC Museum of Anthropology, Vancouver, Gift of Bessie Fitzgerald (bequest), MOA Nb1.708 a-b. Photo Credit: Tim Bonham, MOA.

Thunderbird Earrings, After a Tattoo Design by John Wi'ha, page 54. 1961, sterling silver, 3 cm L × 1.5 cm W, Bill Reid-SFU Art Collection, Gift of Dr. Martine Reid, BRF #19. Photo Credit: Kenji Nagai.

Sculpin Brooch, page 55. c. 1961, sterling silver, 6 cm L × 2.5 cm W, Private collection. Photo Credit: Courtesy of Douglas Reynolds Gallery.

Group of 3 Bracelets: Wolf, Dogfish and Grizzly Bear, page 56. Top: Wolf bracelet, 1962, 22k gold, Nb1. 719, Gift of W.C. and Marianne Koerner;

Middle: Dogfish bracelet, c. 1961, sterling silver, Nb1. 707, Gift of Bessie Fitzgerald (bequest); Bottom: Grizzly Bear bracelet, c. 1958, 22k gold, Nb1. 702, bequest from Bessie Fitzgerald; UBC Museum of Anthropology, Vancouver. Photo Credit: Bill McLennan.

Haida Village, page 57. 1958–1962, cedar, paint, UBC Museum of Anthropology, A50032/b, 2115/4. Photo Credit: Bill McLennan.

Argillite Platter with Killer Whale and Raven, page 58. 1962, argillite, 27 × 17 cm, Courtesy of UBC Museum of Anthropology, Vancouver, Gift of Trevor and Susan Roote, Nb1.748. Photo Credit: Kyla Balley.

Bear Brooch, page 59. 1962, 22k gold, 3 × 4.5 cm, Private collection. Photo Credit: Kenji Nagai.

Bear and Human Earrings, page 60. 1962, 22k gold, 2 cm L × 2 cm W, Bill Reid-SFU Art Collection, Gift of Dr. Martine Reid, BRF #20. Photo Credit: Kenji Nagai.

Raven Brooch, page 61. 1962, 22k gold, 6.3 cm H × 5.4 cm W, Bill Reid-SFU Art Collection, Gift of Dr. Martine Reid with assistance from the Government of Canada and the BRF Trustees, BRF #06. Photo Credit: Kenji Nagai.

Wasgo (Sea Wolf) Sculpture, page 62. 1962, cedar, paint, 1.42 cm H × 0.70 cm W × 2.5 m L, Courtesy of UBC Museum of Anthropology, Vancouver, 211515, A500 29. Photo Credit: Courtesy UBC Museum of Anthropology, Vancouver.

Shaman's Charm Brooch, page 63. 1964, 22k gold, after a Tlingit bone shaman charm collected by Paul Kane and at the ROM, Toronto, 7.2 × 2.9 cm, Bill Reid-SFU Art Collection, Gift of Dr. Martine Reid, BRF #03. Photo Credit: Kenji Nagai.

Box with Lid: "The Final Exam", page 64. 1964, sterling silver, after the painted bent-corner box in the American Museum of Natural History, NY, 10 cm H × 9 cm W × 8.8 cm D, Bill Reid-SFU Art Collection, Gift of Dr. Martine Reid, BRF #04. Photo Credit: Kenji Nagai.

Tschumos Bracelet, page 65. 1964, 22k gold and fossil ivory, 7.0 × 5.3 cm, Private collection. Photo Credit: Reinhard Derreth.

Killer Whale Brooch, page 66. 1964, 22k gold, *Haliotis* shell inlay, 5.5 × 5.7 cm, Private collection. Photo Credit: Courtesy of Douglas Reynolds Gallery.

Thunderbird Earrings, page 67. 1964–1965, 22k gold, fossil ivory, 4 cm L × 2.1 cm W Private collection. Photo Credit: Reinhard Derreth.

Grizzly Bear Brooch, page 68. 1964, sterling silver and argillite, 3.5 × 5.4 cm, Bill Reid-SFU Art Collection, Gift of Dr. Martine Reid, BRF #07. Photo Credit: Kenji Nagai.

Bear and Human Bracelet, page 69. 1965, 22k gold, 7 cm L × 6.3 cm W × 5.2 cm H, Canadian Museum of History, 92-212 (S92-6491). Photo Credit: Courtesy of the Canadian Museum of History.

Bear Sculpture, page 70. 1966, cedar, paint, 1.6 m H × 1.3 m W × 2.1 m L, Courtesy UBC Museum of Anthropology, Vancouver, 2116/1 A500045. Photo Credit: Bill McLennan.

Model Totem Pole with Raven, Bear, Cubs and Frog, page 71. 1966, fossil ivory, 13.93 cm H, Art Gallery of Ontario, Gift of Michael and Sonja Koerner, 2008, 2008/51. Photo Credit: Carlo Catenazzi.

Haida Canoe in a Storm, page 72. 1966, mixed media on paper, 27.9 × 27.7 cm, Canadian Museum of History, VII-B-1854. Photo Credit: Courtesy of the Canadian Museum of History.

Eagle and Frog Bracelet, page 73. 1967, 22k gold, 6.3 cm D × 5.4 cm W, Private collection. Photo Credit: Courtesy of Douglas Reynolds Gallery.

Eagle and Bear Box, page 74. 1967, 22k gold, 10.2 cm H × 11 cm W × 13.3 cm L, Courtesy UBC Museum of Anthropology, Vancouver, Gift of Sonja and Michael Koerner in honour of Walter C. Koerner, Nb 1. 717. A-b, 1483/1. Photo Credit: Bill McLennan.

Raven Earrings, page 75. 1967, 18k gold, fossil ivory, 2.3 × 1.6 cm, Private collection. Photo Credit: Kenji Nagai.

Human Face Cufflinks, page 76. 1967, 18k gold, fossil ivory, 1.6 × 2.8 cm, Private collection. Photo Credit: Kenji Nagai.

Cedar Screen, page 77. 1968, red cedar, laminated, 2.1 m × 1.9 m × 14.6 cm, Courtesy of the Royal BC Museum and Archives, #166 39. Photo Credit: Royal BC Museum, Victoria.

Raven Box, page 78. 1969, sterling silver, 3.7 × 9.5 × 7.8 cm, Vancouver Art Gallery, Gift of J. Ron Longstaffe, #VAG 2002.33.5 a-b. Photo Credit: Courtesy of the Vancouver Art Gallery.

Humanoid Cufflinks, page 79. c. 1969, sterling silver with oxidized background, Bill Reid-SFU Art Collection, Gift of an anonymous donor. Photo Credit: Kenji Nagai.

Panel Pipe, page 80. 1969, argillite; figures from the Bear Mother Legend: Raven, Sea Wolf, Killer Whales and Frog, 27 cm L × 8 cm W × 12 cm Deep, Private collection. Photo Credit: Reinhard Derreth.

Milky Way Necklace, page 81. 1969, 22k & 18 k gold, diamonds, 18 cm inside D, Bill Reid-SFU Art Collection, Gift of Dr. Martine Reid, BRF #97. Photo Credit: Kenji Nagai.

Wolf and Raven Bracelet, page 82. 1969, 22k gold, 5 cm W, Seattle Art Museum, Collection of Fay Hauberg Page. Photo Credit: Paul Macapia.

Eagle Pendant, page 83. 1969, fossil ivory, 18k gold, 5 × 4 cm, Collection of Sherrard Grauer. Photo Credit: Kenji Nagai.

Hawk Moon Pendant, page 84. c. 1970, 22k gold, *Haliotis* shell, 5.5 × 5.2 cm, Private collection. Photo Credit: Courtesy of Douglas Reynolds Gallery.

Eagle Brooch, page 85. 1970, 22k gold, *Haliotis* shell, 6.5 × 4.7 cm, Private collection. Photo Credit: Courtesy of Miriam Shiell Fine Art, Toronto.

Beaver and Eagle Bracelet, page 86. 1970, 22k gold, 6.7 × 6.1 cm, Bill Reid-SFU Art Collection, Gift of Toni and Hildegard Cavelti, BRF #144. Photo Credit: Kenji Nagai.

Spoon with Wolf Design, page 87. 1970, sterling silver, 15.2 cm L, Private collection. Photo Credit: Kenji Nagai.

Mask of a Woman, page 88. 1970, alder, paint, hair, 21 cm H × 16.7 cm W, Courtesy of UBC Museum of Anthropology, Vancouver, 336/148, A, 2617. Photo Credit: Bill McLennan.

Raven Discovering Mankind in a Clamshell, The, page 89. 1970, boxwood, 7.0 cm H × 6.9 cm W, Courtesy of UBC Museum of Anthropology, Vancouver, Nb1.488, 1104/1. Photo Credit: Bill McLennan.

Nanasimgit **Bracelet**, page 90. 1971, 22k gold, 4.5 cm W × 5.5 cm D, Bill Reid-SFU Art Collection, Gift of Dr. Martine Reid, BRF #9. Photo Credit: Kenji Nagai.

Spoon (After a Wooden Kwakwaka'wakw Ladle), page 91. 1971, sterling silver, 15.2 cm L, bowl 5.5 cm, Bill Reid-SFU Art Collection, Gift of Dr. Martine Reid, BRF #18. Photo Credit: Kenji Nagai.

Killer Whale Earrings, page 92. 1971, 22k gold, 2 cm L, Bill Reid-SFU Art Collection, Gift of Dr. Martine Reid, BRF #10. Photo Credit: Kenji Nagai.

Killer Whale Box with Beaver and Human, page 93. 1971, 22k gold, 9.4 cm H × 8.2 cm W × 9.9 cm L, Courtesy of the Royal BC Museum and Archives, #13902 a,b. Photo Credit: Raymond Lum.

Eagle Box with Hinged Lid, page 94. 1971, sterling silver, 8.5 cm H × 12.3 cm L x 7 cm W, Courtesy of the Art Gallery of Ontario, #99/867, Gift of Roy G. Cole and Irene Anderson, Hamilton. Photo Credit: Ian Lefebvre.

Eagle Argilite and Silver Hinged Box, page 95. 1971, sterling silver and argillite, Box 7 × 9.7 × 3.9 cm, Lid (argillite) 8 × 10.5 × 1.5 cm, Private collection. Photo Credit: Kenji Nagai.

Grizzly Bear Pendant/Brooch, page 96. 1972, 22k gold, Haliotis shell inlay, 5 cm D, Private collection. Photo Credit: Kenji Nagai.

Haida Myth of Bear Mother Dish, page 97. 1972, 22k gold, 7.3 cm H × 5.2 cm W × 7 cm L, Canadian Museum of History, IV-B-1574 a,b (s83-368). Photo Credit: Courtesy of the Canadian Museum of History.

Moon Mask Bracelet, page 98. 1972, 22k gold, 6.6 × 6 × 4.4 cm, Art Gallery of Ontario, Gift of Roy G. Cole and Irene Anderson, Hamilton, 1999, 99-862. Photo Credit: Ian Lefebvre.

Children of the Raven, page 99. 1973, serigraph on paper, 76 × 56 cm, Bill Reid-SFU Art Collection, Gift of Dr. Martine Reid, BRF #47. Photo Credit: Kenji Nagai.

Killer Whale Painting, page 100. 1973, acrylic on panel board, 55 cm H × 50 cm W, Bill Reid-SFU Art Collection, Gift of Dr. Martine Reid, BRF #26. Photo Credit: Kenji Nagai.

Haida Dog Salmon—Skaagi, page 101. 1974, serigraph on paper, 56 × 76 cm, Private collection. Photo Credit: Courtesy of CAP and Win Devon Encore Art Group.

Bear Bracelet, page 102. 1975, sterling silver, 4.7 cm H × 5.9 cm D, Private collection. Photo Credit: Kenji Nagai.

Wolf Pendant, page 103. 1976, 22k gold, *Haliotis* shell, 4 cm H × 4 cm W × 1.5 cm D, Bill Reid-SFU Art Collection, Gift of Dr. Martine Reid, BRF #36. Photo Credit: Kenji Nagai.

Pendant with Human Face, Chain and Pedestal, page 104. 1976, 22k gold, pendant 7.6 × 5 × 2.5 cm; stand 5.5 × 1.3 cm, Courtesy of the Seattle Art Museum, Collection of Fay Hauberg Page. Photo Credit: Paul Macapia.

Haida Eagle—*Gut*, page 105. 1978, serigraph on paper, 76 cm H × 56 cm W, Bill Reid-SFU Art Collection, Gift of Dr. Martine Reid, BRF #46. Photo Credit: Kenji Nagai.

Haida Beaver—*Tsing*, page 106. 1978, serigraph on paper, 76 cm H × 57.6 cm W, Bill Reid-SFU Art Collection, Gift of Dr. Martine Reid, BRF #44. Photo Credit: Kenji Nagai.

Wolf Pendant, page 107. 1977, yew wood, Haliotis shell, paint, copper tubing, 18k gold, leather, 8.3 cm H × 7.1 cm W, Courtesy of UBC Museum of Anthropology, Vancouver, Gift of Bill Reid (bequest), 2776/1. Photo Credit: Kenji Nagai.

Skidegate House Frontal Pole, page 108. 1978, cedar, 18 m, Skidegate Band Council, Gift of Bill Reid to the Skidegate people, Photo Credit: Dr. Stanley Lubin.

Horse Barnacle Necklace, page 109. 1979, white gold and sterling silver, 13 cm D, Bill Reid-SFU Art Collection, Gift of Dr. Martine Reid, BRF #98. Photo Credit: Kenji Nagai.

Eagle, Salmon, Bearded Man Bracelet, page 110. 1979, sterling silver, 5.3 cm W × 7.4 cm D, Private collection. Photo Credit: Kenji Nagai.

Haida Wolf—*Godji*, page 111. 1979, serigraph on paper, 76 cm H × 56 cm W, Bill Reid-SFU Art Collection, Gift of Dr. Martine Reid, BRF #45. Photo Credit: Kenji Nagai.

***Nanasimgit* Wall Hanging**, page 112. 1980, serigraph on raw silk, 138.5 cm H × 80 cm W, Bill Reid-SFU Art Collection, Gift of Dr. Martine Reid, BRF #105. Photo Credit: Kenji Nagai.

Raven and the First Men, The, page 113. 1980, laminated yellow cedar, 1.88 m H × 1.92 m W, Courtesy of UBC Museum of Anthropology, Vancouver, ANb1.481.689/1. Photo Credit: Bill McLennan.

Bear Head, page 114. 1981, bronze, 73 cm w, Bill Reid-SFU Art Collection, Gift of Dr. Martine Reid, BRF #16. Photo Credit: Kenji Nagai.

Killer Whale Painting, page 115. 1981, acrylic paint on paper, 41 × 54 cm, Private collection. Photo Credit: Kenji Nagai.

Bear Mother and Her Husband, The, page 116. 1982, graphite on paper, 58 × 44.8 cm, Private collection. Photo Credit: Unknown.

Dogfish Woman Transformation Pendant, page 117. 1982, boxwood, 18k gold, 8.0 cm D, Bill Reid-SFU Art Collection, Gift of Dr. Martine Reid, BRF #99. Photo Credit: Kenji Nagai.

Killer Whale, page 118. 1983, boxwood, 11.5 cm H × 4.3 cm W, Bill Reid-SFU Art Collection, Gift of Dr. Martine Reid, with assistance from the Government of Canada and the BRF Trustees, BRF #14. Photo Credit: Kenji Nagai.

Dogfish Woman, The, page 119. 1983, graphite on paper, 58 × 44.8 cm, Private collection. Photo Credit: Unknown.

Nanasimgit **and His Wife**, page 120. 1983, graphite on paper, 44.8 × 58 cm, Private collection. Photo Credit: Unknown.

Killer Whale Spirit, page 121. 1983, bronze, 37 cm D, Private collection. Photo Credit: Kenji Nagai.

Mythic Messengers, page 122. 1984, bronze, 8.5 m × 1.2 m × 45.7 cm, Bill Reid-SFU Art Collection, Gift of BCE Inc., BRF #114. Photo Credit: Kenji Nagai.

Killer Whale on Wave Base, page 124. 1984, bronze, 132.08 cm H, Bill Reid-SFU Art Collection, Gift of Dr. Martine Reid, BRF #42. Photo Credit: Kenji Nagai.

Phyllidula—The Shape of Frogs to Come, page 125. 1984–1985, cedar, stain, 42.5 cm H × 87 cm W × 1.19 m L, Vancouver Art Gallery #86.16. Photo Credit: Courtesy of the Vancouver Art Gallery.

Skaana—**Killer Whale, Chief of the Undersea World**, page 126. 1984, bronze, 5.5 m H, Collection of the Vancouver Aquarium. Photo Credit: Emma Peter.

Three Whales for South Moresby, page 127. 1986, lithograph on paper, 50.56 × 30.72 cm, Bill Reid-SFU Art Collection, Gift of Dr. Martine Reid, the Government of Canada and the BRF Trustees, BRF #22. Photo Credit: Kenji Nagai.

Raven and the First Men, The, page 128. 1986, onyx, 73.66 × 50.8 cm, Bill Reid-SFU Art Collection, Gift of W. Maurice and Mary Margaret Young, BRF #142. Photo Credit: Kenji Nagai.

Bull Wire Sculpture, page 129. 1986, 18K gold, 5.76 cm H × 6.4 cm L × 2.56 cm D, Bill Reid-SFU Art Collection, Gift of Dr. Martine Reid, BRF #70. Photo Credit: Kenji Nagai.

Lootaas, **Wave Eater**, page 130. 1986, cedar, paint, 15 m L, Collection of the Haida Heritage Centre at Kaay Llnagaay, Gift of the Hong Kong Bank of Canada. Photo Credit: Rolf Bettner.

Wealth Sound Lady Necklace, page 131. 1988, 22K gold, *Haliotis* shell, fossil ivory, pendant 5 × 4.3 cm, collar 43 cm L, Bill Reid-SFU Art Collection, Gift of Dr. Martine Reid, BRF #13. Photo Credit: Kenji Nagai.

Cluster of Seven Frogs Necklace, page 132. 1988, 22k gold, *Haliotis* shell, 14 cm inner D, Bill Reid-SFU Art Collection, Gift of Dr. Martine Reid, BRF #12. Photo Credit: Kenji Nagai.

Haida Beaver Pole, page 133. 1990, 22k gold, 5.9 cm H × 2.8 cm sq base, Bill Reid-SFU Art Collection, Gift of Dr. Martine Reid, BRF #58. Photo Credit: Kenji Nagai.

Xhuwaji—**Haida Grizzly Bear**, page 134. 1990, serigraph on paper, 58.64 cm H × 56.64 cm W, Bill Reid-SFU Art Collection, Gift of Dr. Martine Reid, BRF #60. Photo Credit: Kenji Nagai.

Spirit of Haida Gwaii Maquette, The, page 135. 1990, plaster and steel, 3.89 m H × 6.05 m L × 3.48 m W, Canadian Museum of History, 92-51 (S92-9152). Photo Credit: Courtesy of the Canadian Museum of History.

Spirit of Haida Gwaii, The, The Black Canoe, page 136. 1991, bronze, 605 cm L × 389 cm H × 348 cm W, Collection of Government of Canada, funded by Nabisco Corporation. Photo Credit: Gary J. Wood/Flickr, CC BY SA 2.0.

Dogfish Woman Transformation Necklace, page 137. 1991, 22k gold, pendant 9 cm H × 10 cm W, collar 14 cm D, Bill Reid-SFU Art Collection, Gift of Dr. Martine Reid, the Government of Canada and the BRF Trustees, BRF #21A. Photo Credit: Kenji Nagai.

Dogfish Mural, page 138. 1991, paper cast, 198.51 cm H × 78.12 cm W, Bill Reid-SFU Art Collection, Gift of Dr. Martine Reid, the Government of Canada, the BRF Trustees, BRF #57. Photo Credit: Kenji Nagai.

There Are Two Sides to Every Story, page 139. 1991, collage on paper, mixed media, with photographs by Ulli Steltzer, 56.32 cm H × 72.32 cm W, Bill Reid-SFU Art Collection, Gift of Dr. Martine Reid, BRF #69. Photo Credit: Kenji Nagai.

Dogfish Woman, page 140. 1991, bronze with black patina, 85 × 77 × 97 cm, Private collection. Photo Credit: Kenji Nagai.

Bear Mother, page 141. 1991, bronze with black patina, 70 × 60 × 87 cm, Private collection. Photo Credit: Kenji Nagai.

Speaker Staff, page 142. 1991, bronze with jade patina, granite, 176 cm H; granite base, 35 cm sq., Private collection. Photo Credit: Kenji Nagai.

Swg'ag'ann—Sockeye Salmon Pool, page 143. 1991, serigraph on paper, 56 cm H × 76 cm W, Bill Reid-SFU Art Collection, Gift of Dr. Martine Reid, BRF #49. Photo Credit: Kenji Nagai.

Grizzly Bear Necklace, page 144. 1992, silver, Haliotis shell, fossil ivory, pendant 7.04 cm D, collar 42.88 cm L, Bill Reid-SFU Art Collection, Gift of Dr. Martine Reid, BRF #108. Photo Credit: Kenji Nagai.

Cat Wire Sculpture, page 145. c. 1993, metallic wire, 12 cm W, Bill Reid-SFU Art Collection. Gift of Herb and Mary Auerbach, Photo Credit: Kenji Nagai.

Xaxada—Haida Dogfish, page 146. 1993, monochrome woodcut on paper, 65.92 cm H × 52.48 cm W, Bill Reid-SFU Art Collection, Gift of Dr. Martine Reid, BRF #67. Photo Credit: Kenji Nagai.

Spirit of Haida Gwaii, The, The Jade Canoe, page 147. 1993, bronze, 6.05 m L × 3.89 m H × 3.48 m W, Courtesy of the Vancouver International Airport. Photo Credit: Tony Hisgett/Flickr, CC BY 2.0

Mythic Messengers Bracelet, page 148. 1994, 22k gold, 18 cm D, Private collection. Photo Credit: Kenji Nagai.

Xaxada—**Haida Dogfish**, page 149. 1994, bichrome woodcut on paper, 88 cm H × 80 cm W, Bill Reid-SFU Art Collection, Gift of Dr. Martine Reid, BRF #48. Photo Credit: Kenji Nagai.

Haida Beaver Totem Pole, page 150. 1997, coloured etching on handmade paper, 74.24 cm H × 53.12 cm W, Bill Reid-SFU Art Collection, Gift of Dr. Martine Reid, BRF #59. Photo Credit: Kenji Nagai.

Haida Beaver Totem Pole, page 151. 1997, monochrome etching on handmade paper, 74.24 cm H × 53.12 cm W, Bill Reid-SFU Art Collection, Gift of Dr. Martine Reid, BRF #66. Photo Credit: Kenji Nagai.

Haida Angel, page 152. 1997, copper etching on handmade paper, 81.26 cm H × 55.04 cm W, Bill Reid-SFU Art Collection, Gift of Dr. Martine Reid, BRF #68. Photo Credit: Kenji Nagai.

Unfinished Drawing of Central Figure of the Spirit of Haida Gwaii, page 153. 1997, copper etching on paper, 36 cm H × 28 cm W, Private collection. Photo Credit: Courtesy of Douglas Reynolds Gallery.

Acknowledgements

THE BILL REID Foundation and Martine Reid are very grateful to the Audain Foundation for the Visual Arts in British Columbia and to Frank Anfield, a Bill Reid Foundation's Director Emeritus, for the necessary and much appreciated financial support for this book's photographic content and project management.

We are also grateful to Alexandra Montgomery, Executive Director and CEO, Bill Reid Gallery (BRG), for endorsing the project with great enthusiasm; to Catherine Crough, BRG staff member and volunteer; Meredith Areskoug, BRG marketing and sales associate; and Susan Shir, BRG accountant, for their invaluable logistical support; and to Dr. Rodney A. Badger and editor Linda Stanfield for their careful reading of the manuscript.

We also wish to thank the following institutions for their generous collaboration:

Art Gallery of Ontario
The Bill Reid Centre for Northwest Coast Art Studies, Simon Fraser University
Bill Reid Estate
British Museum
Canadian Art Prints and Winn Devon Encore Art Group
Canadian Museum of History
Royal BC Museum and Archives
Seattle Art Museum
Vancouver International Airport
University of British Columbia (UBC) Museum of Anthropology
Vancouver Art Gallery

Many private and public collectors have also granted us permission to use photographs of their Bill Reid pieces, for which we are grateful.

We would also like to thank Bill McLennan, Kenji Nagai, Eliza Massey, Dr. George MacDonald, Reinhard Derreth, Raymond Lum, Rolf Bettner, Paul Macapia, Ian Lefebvre, Trevor Mills, Larry Goldstein and Dr. Stanley Lubin for their photography, as well as the Douglas Reynolds Gallery, Inuit Gallery and Miriam Shiell Fine Art.

24 25 26 27 28 — 7 6 5 4 3

Douglas and McIntyre (2013) Ltd.
PO Box 219, Madeira Park, BC, V0N 2H0
www.douglas-mcintyre.com

Cataloguing data available from Library and Archives Canada
ISBN 978-1-77162-115-1 (paper)
ISBN 978-1-77162-116-8 (ebook)

Editing by Pam Robertson
Copyediting by Kyla Shauer
Cover image: *Wolf Pendant*, 1976, 22k gold, Haliotis shell, 4 cm H × 4 cm W ×
 1.5 cm D, Bill Reid-SFU Art Collection, Gift of Dr. Martine Reid, BRF #36.
 Photo by Kenji Nagai
Frontispiece: Xaxada—*Haida Dogfish*, 1994, bichrome woodcut on paper,
 88 cm H × 80 cm W, Bill Reid-SFU Art Collection, Gift of Dr. Martine Reid,
 BRF #48. Photo by Kenji Nagai
Back cover photograph: Bill Reid with *The Bear Mother* and *The Dogfish Woman*,
 1989, photograph, 20 cm x 20 cm, Private collection. Photo by Eliza Massey
Printed and bound in Korea

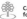 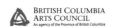

Douglas and McIntyre acknowledges the support of the Canada Council for
the Arts, which last year invested $157 million to bring the arts to Canadians
throughout the country. We also gratefully acknowledge financial support
from the Government of Canada through the Canada Book Fund and from
the Province of British Columbia through the BC Arts Council and the Book
Publishing Tax Credit.